INCOMPARABLE
WOMEN OF STYLE

This book is dedicated to my dear friend Manuel Santelices whose critical eye and endless patience helped bring this project to fruition.

ROSE HARTMAN

INCOMPARABLE
WOMEN OF STYLE

Texts by Anthony Haden-Guest, Rose Hartman, and Alistair O'Neill

ACC EDITIONS

© 2012 Rose Hartman

World copyright reserved

ISBN 978-1-85149-699-0

The right of Rose Hartman to be identified as author of this work has been asserted by her in accordance with the Copyright, Designs and Patents Act 1988

All rights reserved. No part of this publication may be reproduced, stored in a retrieval system or transmitted in any form or by any means electronic, mechanical, photocopying, recording or otherwise, without the prior permission of the publisher

Designer: Craig Holden
Editor: Catherine Britton

British Library Cataloguing-in-Publication Data
A catalogue record for this book is available from the British Library

Printed in China for ACC Editions, a division of the Antique Collectors' Club, Woodbridge, Suffolk

Acknowledgements

I woud like to thank my agents, Jane Lahr and Lyn DelliQuadri who never gave up, ACC's John Brancati and Marco Jellinek who never wavered in their belief in *Incomparable: Women of Style*.

I also want to thank those friends and associates, including Andrea Blanch, Ivy Brown, Carole Alter, Nin Bruderman, Linda Troeller, and Marguerite Ruscito, my agent at Getty Stock Agency who willingly viewed and critiqued my images during the last two years.

Special thanks to Alistair O'Neill who wrote such a compelling introduction, as well as Anthony Haden-Guest, whose essay on my work was so incisive. A shout-out goes to Karen Cannell, who has acquired my thirty-five-year archives for the Fashion Institute of Technology's important collections, and F.I.T.'s Museum Director, Valerie Steele who suggested that Ms. Cannell view my collection. And a million thanks to Spectra Lab's Jack Barlev, who tirelessly prepared and critiqued my images.

Finally incomparable thanks to all those women whose distinctive, personal style made photography an endless joy!

Rose Hartman, 2012

CONTENTS

INCOMPARABLE: Women of Style
Anthony Haden-Guest

It would be easy to imagine that the work of photographers covering the fancier rituals of metropolitan life – the premieres, the swells at velvet-corded openings, fashionistas at events promoting this, that and the 'Absolutely Fabulous' other, the passagiettas on the boulevards – would share a routine shimmer. In fact, the best-known practitioners are quite unalike. Bill Cunningham, who haunts the streets, has a gift for easy intimacy; Ron Galella is outsiderish, sometimes to the point of the confrontational; Jessica Craig-Martin is reportagey, sometimes sardonic and sharp-edged.

And Rose Hartman?

Hartman is always in full 'I-Am-A-Camera' mode. Pink-haired Zandra Rhodes becomes a vivid viridian forcefield, Paloma Picasso looks like a matador quite ready to punch out any bull in the arena and Betsey Johnson is a whirlwind. 'She always runs out at the end of her shows' Hartman says. 'And she does a cartwheel at the end. She hasn't stopped in all these years. 'Hartman doesn't impose herself as a studio photographer will. Iman sweeps by, Bowie in tow, neither giving her a glance. Nor does she impose a mood. A raccoon-eyed Carla Bruni, her lower lip glimmering like sucked candy, looks smolderingly ready to implode.

The world that Hartman is covering here is, of course, one which is all about style but, seen through her eyes, style is not an artificial construct, not confectionary. It has substance, and she hones in on it with no tweaking, styling, or Photoshopping. Anna Wintour actually does look like that, and over and over. As do Kate Moss, Carmen, Christy Turlington, and Daphne Guinness – in a whole gallery of glittery pictures – and as do Nan Kempner and Tina Chow.

There are – inevitably in an oeuvre that covers several decades of evanescence – some images here that sweep you back to times past in a manner both ravishing and poignant. Audrey Hepburn's sheer delight at being kissed on the forehead from a great height by Hubert de Givenchy evokes an era when haute couture was truly haute. And here is Jerry Hall listening to an Andy Warhol who is not the 'Wow' speaker of myth but in torrential conversational mode. At a Larry Rivers opening, Hartman looks over and sees Fred Hughes and Elsa Peretti. They each pick up a cigarette and light up as precisely together as synchronized swimmers. 'I didn't say anything. I just took the photograph,' Hartman says. And here is Toko, the cherubic Japanese supermodel. She is standing outside Roseland after a fashion show, looking for a cab. She is wearing full kabuki makeup, and she too lights up.

The Age of the Cigarette: so near, so far. 'She wasn't posing,' says Hartman, who got that picture too.

Anthony Haden-Guest is a British-American writer and cartoonist.

Introduction
Alistair O'Neill

"Of course what you want to do is make every reader feel Johnny on the spot in the centre of things."
"As if she were having lunch at the Algonquin."
"Not today but tomorrow," added Ellen.

The desire to get to the centre of things lies at the heart of *Manhattan Transfer*, John Dos Passos' novel set in 1920s New York. When Ellen, the book's central character meets Mr Harpsicourt, the likely publisher of a women's magazine, he explains the position he hopes she will take. Ellen's reply lets us know that to sit at Dorothy Parker's round table of wit and style is not enough, and that to really feel in the midst of it - to really feel wanted - you need that churn of anticipation and the assurance that a place is set and waiting for you. To look at Rose Hartman's photographs is to get that 'Johnny on the spot' feeling, in the sense that they're not just fascinating documents of roped-off, at-the-heart-of-it moments; they also usher us in and sense our arrival. And what a blast that is.

For over thirty years Hartman has photographed what someone like Cecil Beaton might once have described as New York Society, but her photographs show us how the definition of people at the centre of things has essentially changed. Take two photographs of people smoking. The first, of socialite Nan Kempner and jewelry designer Kenneth Lane, conveys the pleasures of social form, the observation of dress codes and the kind of assurance that produces ease - right down to the downward line of the cigarettes. This is the poise of the high life held at the wrist. Another, of *Interview* magazine's Fred Hughes and jewelry designer Elsa Peretti, is a study in smoky detachment. Rather than acknowledging the camera as Kempner does, they pose for it sideways; their hands open as gestures that pull drags from cigarettes and cast eyes adrift. This isn't style as nature, but style engineered as affectation.

If one photograph speaks of entitlement, then the other speaks of agency; but both are about the embodiment of style in 1970s New York, played across bodies, clothes and surfaces. Hartman came to prominence for her fearless portrait of the New York fashion industry, *Birds of Paradise: An Intimate View of the New York Fashion World*, published in 1980. But to consider it a pictorial account of the garment district at work (what Hartman liked to call the 'chiffon jungle'), is misleading. For perhaps more than any other era in the history of New York fashion, this was when the acumen and design of the day was coordinated with the choreography and opportunities of the night. It is something of a paradox that New York secured its position as a fashion capital of international standing at a time when the best way for a publicity department to place a designer, was to get them photographed partying. Hartman characterised her area of study as 'really about the irrevocable, intricately-orchestrated pattern of events and energies that make fashion the heady experience that it is.' But fashion is only one of the many creative communities who feature in Hartman's photographs.

She is one of the first documenters of what Elizabeth Currid has more recently defined as *The Warhol Economy*: how fashion, art and music in New York are networked through 'the significance of New York's informal social life in cultivating the fluidity of creativity'. Andy Warhol is credited for the way he contributed to and made his presence felt at the heart of this interaction. This is the man who started *Interview* magazine so that he could meet more people and get invited to more parties. Pick up any issue and it can be read as an extended conversation round a table, or at a party with all manner of people with

something to say about being creative. (Incidentally, one of Hartman's favourite photographs is of Warhol in conversation with the model Jerry Hall at an *Interview* party in 1977, unconventional according to the photographer because, 'Andy never talked'.)

What is unique about Hartman's contribution is the attention she pays to the role of women in this social world, not as accessories or mannequins but as active contributors through the agency of their style: as being beyond comparison. As a Kublah Khan of the creative imagination, New York in the seventies had Studio 54 as its Xanadu, and the true surviving fragment is Hartman's photograph of Bianca Jagger riding a white horse into the nightclub to celebrate her thirtieth birthday. Within all of the maelstrom that must have ensued is captured a still image of certainty and command, particularly for the way Jagger controls the horse without saddlery wearing the most fluid kind of jersey dress by Halston. And while she looks away with studied indifference, the horse's eye remains trained on the camera.

That the photograph exists is because of Hartman being there, not as a photographer with a press pass, but as an invited guest with a camera. (She often hid her camera in a speaker if she wanted to dance.) It afforded Hartman the position of being one of the first photographers to capture these new forms of currency within an image-orientated economy traded internationally. Writing in 1973 as the fashion correspondent of *The New Yorker*, Kennedy Fraser noted in an essay about modern style that Bianca Jagger was the example *par excellence*: 'That even her most triumphant effect must be ephemeral - a unique combination of dress, light, and the evening's particular mood in her eyes - makes the undertaking superbly dandylike.'

Stylish women borrowing from the dandy's wardrobe was nothing new. Chanel had mined the colour black for its poetic implications in the clothes she developed in the 1920s, but this new cult of appearance took the idea of duration as its theme - condensing a look into the fraction of a camera's shutter speed. Hartman noted this new notion of dressing in *Birds of Paradise* after a conversation with Nan Kempner: 'Kempner recalled one evening when she looked especially glamorous at a party and couldn't help thinking, "It's such a pity that *Women's Wear* [Daily] isn't here"'.

As a self-taught photographer with a career bound by chance and opportunity, Hartman's work has often resisted categorisation, but this is in essence its strength and contribution. She started as a columnist in *Soho Weekly News* in the mid-1970s covering the gallery openings and events that marked the gentrification of the district; or as Robert Hughes, an early devotee of Soho once put it, 'Come the dawn, come the boutique.' After being abandoned on more than one assignment by an errant staff photographer, Hartman took the matter in her own hands and enrolled on a short photography workshop. One of her first commissions was to cover the wedding of Hemingway's granddaughter Joan for the men's fashion newspaper *Daily News Record*, which prompted her work as a commercial photographer operating across diary pages and society columns, art features and fashion articles.

If there is an overarching theme to her photographs, it is an informality - a quality often found at art openings but always in short supply at fashion shows. What this reveals is a sense of Hartman herself, as a figure who moves between these distinct worlds with ease. In her continuing work as a New York columnist she is often referred to as 'Rambling Rose', with all it implies about her travels around Manhattan covering the latest events: from Bryant Park over to the other side of the High Line; or from Seventh Avenue up to Museum Mile. As a long time resident of Greenwich Village, Hartman shares her sense of the city with that other great downtown woman, Jane Jacobs. In her 1961 book,

The Life and Death of Great American Cities, Jacobs describes the logic of Manhattan as not being the grid, but the sense of people on the move.

It is a complex order. Its essence is intricacy of pavement use, bringing with it a constant succession of eyes. This order is all composed of movement and change, and although it is life, not art, we may fancifully call it the art form of the city and liken it to the dance.

Hartman is the great chronicler of this urban shimmy, as she shifts in and out of the city's districts and into those momentary spaces and places that are not advertised nor located on maps, arriving at events that seem to light up as temporarily as her flashbulb. When interviewed for *Women's Wear Daily* about the donation of her archive to the Special Collections of the Library of the Fashion Institute of Technology in 2011, Hartman confirmed that it is the staccato rhythm of the city that she follows over any form of composure: 'Basically, the photos you will see in the exhibition, these are moments. I was not really setting up anything.'

And this sense of things being loose - not yet ready, in process - is her legacy. Contemporary fashion imagery now pays as much attention to backstage at a fashion show, to what the models wear as they arrive, than what they wear on the runway. Unlike the photographer taking the catwalk shots at the end of the T-bar, or the one commissioned to do the look book, or those camped outside taking photographs of guests as they arrive, Hartman has resolutely remained a roving free agent - moving between chairs, sidling up to the make-up artist. Her position has been undeniably influential on how fashion shows are now managed and communicated as images to a global audience.

But the fashion show is only one kind of space. Be it the exhibition opening, the dinner, or the dance at a club, Hartman is there ready to rise to the open-ended proposition of the evening. To see her in action is to see an infectious sense of enjoyment at play, as she works the room as might any guest, with a sense of inquisitiveness at what stands for interaction at heart. So it might be calling out to Polly Mellen as she turns to greet her on a staircase, observing the solitary detachment that a cigarette brings to Chloë Sevigny, or that moment at which Daphne Guinness raises her eyes at a table. As moments they might be meaningless, but somehow they are also matchless.

Within these photographs Hartman delineates a quality particular to New York women of style. The kind of women who call the city home but who are familiar to many others; the kind who define an internationally-followed lexicon of what it is to be regarded when looked at. It is a point of distinction first made by Cecil Beaton in his portrait of the city, that 'the affectation is to be natural: not to be natural, but to *affect* being natural; the difference is more than subtle'. It is a subtlety learnt by studying how pose and gesture operate differently in an image than they do when performed without a camera. And these women have learnt this by studying Hartman's photographs. Beaton also observed how New Yorkers lead their lives out and about with little recourse to what could be called a private life. In this he realized that the true rhythm of the city is its invitation, one to which Hartman and all those other women of style are still in thrall:

Life is never free and easy in New York. One has too little to do or too much. In no other city must existence be planned so carefully. Not to go out is to be forgotten, but one invitation out leads to a dozen more.

Alistair O'Neill is Reader at Central Saint Martins College of Arts and Design, London.

Autobiography
Rose Hartman

'Fashion fades. Only style remains forever.' - Coco Chanel

When I discovered *Vogue* magazine at the age of eleven or twelve, I was immediately transported to a world of intricate, fantasy-oriented images worn by immaculately-styled models. I spent endless hours scrutinizing every detail of their outfits and devouring the comings and goings of a gilded infantry who always wore beautifully-cut clothes and flitted, swanlike, from gala to gala, with sporadic visits to rejuvenating spas and holidays in St. Barts, Rajasthan, Gstaad and other exotic locales.

Describing his reactions to the great fashion magazines, Yves St. Laurent, wrote: 'I see myself once more. I am very young. Feverishly I wait each month for them... From their satin paper, I receive ripples of passion…' Perhaps his comments were just a little exaggerated, but they were my sentiments as well.

Vogue became my bible, with its never-ending visual enticements and provocative questions: 'Why is November so dazzlingly different?' a *Vogue* editorial asks. 'The quick, unexpected turn that is the difference between dazzle and dazzzzle,' it replies; then tells the breathless readers (myself included) what feels right this month.

At the very least, I could have a glamorous life….vicariously.

Growing up in the East Village in a sixth-floor walk-up, I remember my mother wearing elegant, draped velvet dresses, faux diamonds, long gloves and head-turning hats, all painstakingly sewn by a local dressmaker. Mother was another of *Vogue's* acolytes.

After graduating from Hunter High, an elite school filled with stylish students whose school "uniform" was a combination of plaid wool skirts, cashmere sweaters and pearls, I received a liberal arts degree from City College New York, before teaching high school english. Like most women of my generation, teaching or nursing seemed the most viable options. I did not plan to be a photographer, but my relentless curiosity and passion for visual art took me in a new direction. To augment my teacher's salary, I began taking freelance jobs which led to a weekly column in the *Soho Weekly News*. I interviewed the new residents of Soho's rough but burgeoning art community.

I loved the job but became frustrated when the photographer who accompanied me on assignments arrived late.

Encouraged by several artist friends, I decided to enroll in a summer photo workshop in Sun Valley, Idaho. That same week, Joan Hemingway (Ernest's granddaughter) was to be married on her family's estate to restaurateur and men's fashion boutique owner Jean DeNoyer. Through a personal contact at the *Daily News Record*, a Fairchild publication, I was asked to photograph their wedding. It was my foray into the same world that was a mainstay of *Vogue's* lifestyle pages. Beautiful, sylphlike women in marvelous clothes were my willing subjects; there were no staged photographs of the bride and groom or of the wedding party. Having never captured a wedding before, I didn't think to set up conventional posed shots - a practice that I have continued for the last thirty-five years.

After shipping my unprocessed film to New York, my first view was a fresh copy

of *Daily News Record* on a news stand. I wound up with the cover headlining, 'A Moveable Feast'. I had met amazing people, made money, and produced work that was spontaneous, and appreciated by fashion editors.

My career was born.

It was time to enter the chiffon jungle. By making contacts with all-powerful publicists, I quickly gained access to cover the most exclusive clubs, parties and events.

In order to insure that my name would appear on guest lists, I made sure that my tear sheets were sent to all the 'right people'. If I was lucky enough to get an exclusive shot (being in the right place at the right time was key), my stock agent could easily sell the same image over and over again to dozens of international magazines (a shot of John Kennedy Jr. and Carolyn Bessette entering a gala was especially popular).

Endless hours spent researching important upcoming events along with many phone calls would result in being granted permission to enter limited-access areas — and I was one of the few woman in the male-dominated photography field. In 1977, I began work on my first book, *Birds of Paradise: An Intimate View of the New York Fashion World*. At the beginning of my career, I was most interested in the way that previously unremarkable-looking models were transformed into hothouse flowers who exuded attitude, poise and a total lack of interest in the mundane. While these exotic creatures dined on champagne and cigarettes before each show, I moved around backstage like a fly on the wall, managing to capture some of the decades' supermodels as hair and make-up people emphasized their looks.

Then I took my place at the edge of the catwalk to record each show. I must admit that backstage was far more interesting image-wise. Perhaps it was the combination of controlled chaos and being privy to a cloistered world unavailable to the public that made it such a special experience.

In between photographing fashion shows, I searched for elegant subjects around the world. Whether in St. Petersburg or Mumbai, stylish women, on the street or at private events, were my sought-after prey.

Some of my favorite subjects (who I have captured decade after decade) include designers Donna Karan, Betsey Johnson, Diane Von Furstenberg, Carolina Herrera and Vivienne Westwood; models like Iman, Jerry Hall, and Naomi Campbell; muses like Daphne Guinness, Tina Chow and Kate Moss; the jet-set coterie like Bianca Jagger, Nan Kempner, and Amanda Hearst; the fashion media's Anna Wintour, Diana Vreeland, and Carine Roitfeld; and the dress-to-impress fashionistas, whose style drove high fashion from the city's club scene into the mainstream. Their looks were a veritable fashion playground and a laboratory of style. Wherever the fashionistas partied, it was likely that a top designer and his or her assistants would be nearby.

Of course, the atmosphere of New York City, with its select bars, private restaurants and hedonistic nightclubs such as Xenon, the Mudd Club, Area, and MK, presented the perfect backdrop for those nocturnal, iridescent creatures who continue to command attention whenever they enter any room. Given the opportunity to observe such women in countless venues: gallery openings; dinner parties; fashion shows; out-of-the-way clubs and private cocktail receptions, I was able to record fashion history. My criteria: glamorous women who exuded charisma and self-confidence or amusing, young self-starters with an instinctive sense of style who absorbed everything they saw on their constant travels.

An invite from a publicist to cover a fabulous event for a magazine – a week-long trip to France with the American Friends of Versailles – would prove invaluable in my ever-growing archive of striking subjects.

Like the renowned photographer Brassai who was able to get inside the 1930s Parisian bordellos and capture the intimacy of that private world so brilliantly, I opted for Studio 54, the legendary watering hole of the chic international crowd. Dressed in black (to avoid any kind of attention), I entered a world of hedonism, celebrity sizzle, and all manner of individual fabulousness.

There were neither bodyguards nor huge posses around a celebrity, making it easy to get a clean shot, and co-owner Steve Rubell's generosity made it all possible. I virtually had an all-access pass and would never have to wait in line to enter this fantastic world, where women would spend hours getting ready for their grand entrance.

In my role of social historian, I would watch my intended subject or simply chat with her. In some cases, I would simply wait for the 'decisive moment' (a method used by Henri Cartier Bresson, one of my favorite photographers). I might chat with one person, but watch another person out of the corner of my eye. As soon as I spotted the more vulnerable expression, I would quickly pick up my camera and take the picture, and catch the private persona.

One night, in 1977, around 2 a.m., I was as shocked as Baryshnikov, Halston and other guests to see Bianca atop a white horse. I fired two or three shots to capture the picture that went round the world, the picture that encapsulated an era when decadence ruled. Bianca was only there for a moment, because having a horse inside Studio 54 under disco lights might have become very dangerous. Bianca has always been one of my favorite women of style, but on that particular night, dressed in a simple, chic Halston original, she epitomized an individual of great personal elegance.

Studio 54 was also where I noticed a stunning Jerry Hall gossiping with Andy Warhol at an *Interview* magazine party. Andy rarely spoke, so capturing that unscripted moment was quite special. Some years later, I had the chance to photograph Jerry Hall in Mustique; as stylish as ever.

Most recently, I photographed rarified style icon Daphne Guinness, a woman who lives and breathes clothing and adornment. Dressed in one of her dare-to-wear outfits, topped with a delicate Philip Tracey veil covering her entire face, Daphne chatted with a guest at a private dinner honoring David LaChapelle. I watched and waited, until she turned her face, revealing her striking profile. It took a second, over three decades of honing my skills, to produce an image that epitomizes my continuing theme: a woman who never bows to trends.

I often have to explain to non-believers that my images are never set up, never staged; instead, I wait until I see an expression that moves me and then I shoot - not before, not after. I want as much spontaneity as possible. Celebrities with smiles tattooed on to their faces do not interest me.

If my subject is a jet setter, her clothes will be gorgeous but often predictable (the perfect designer suit, shoes and bag), but if an anonymous style maven crosses my path, nowadays, I am much more eager to capture her. Whether elegant or whimsical, she is a true original - in control of her sensibility. She might discard lovers or friends, but she would never abandon style. As the formidable Diana Vreeland told *Vogue*, 'I don't think

you have it one day and not the next. You have it getting into bed. You have it when you have a temperature of 103 and are moaning. It's you - that's all your style is. Whatever you have comes out of your style.'

And who knew more about style than the incomparable doyenne, D.V.?

For the technically-curious reader: for the last thirty-five years, I have taken thousands of black-and-white negatives and color slides that have been published in hundreds of international publications: *Vogue, Vanity Fair, Harper's Bazaar, Stern, Panorama, New York, Allure*. Initially, I used a manual, 35mm-Olympus, and transitioned to a Cannon system with its more practical automatic settings. Once, my skills were fine-tuned, I entered the digital age. I am happiest shooting with a pocket-size Lumix equipped with a Zeiss lens which guarantees I can get the shot that I want without having to sacrifice spontaneity.

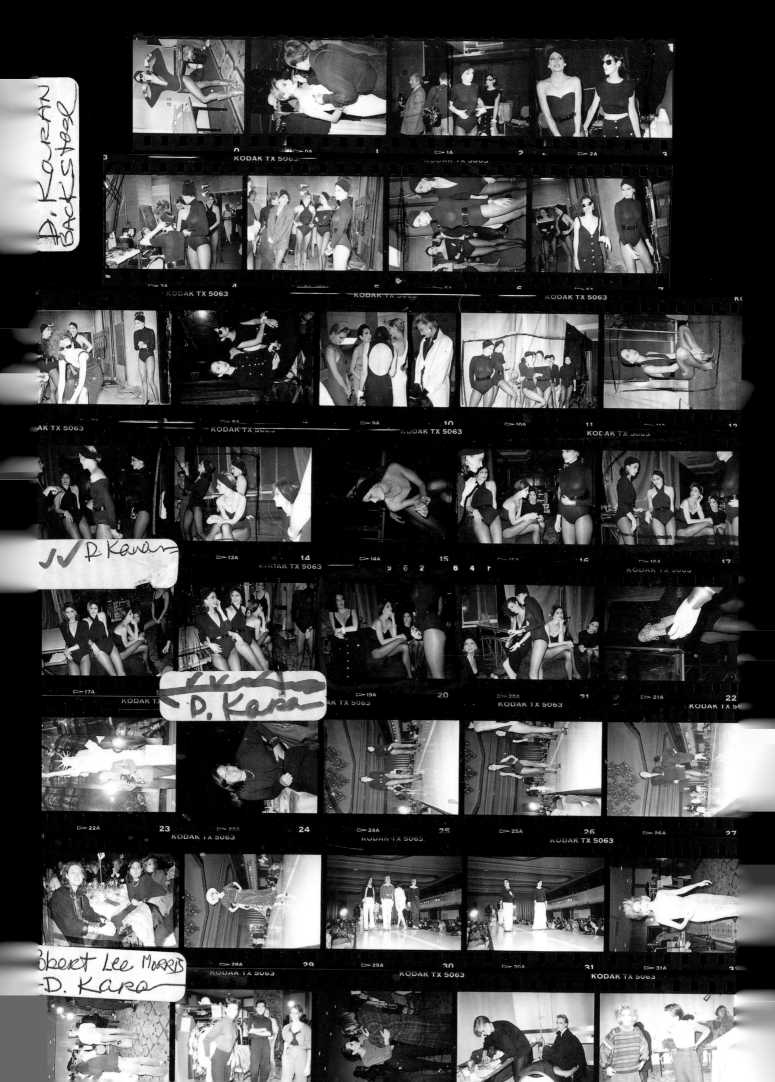

D. KORAN
Backstage

√ D Karan

D. Kara

Robert Lee Morris
D. Kara

MODELS

Kristen McMenamy, Bill Blass fashion show, Bryant Park tents,
New York, 1994

▸ Kristen McMenamy, Allure magazine party, Soho loft,
New York, circa 1990s

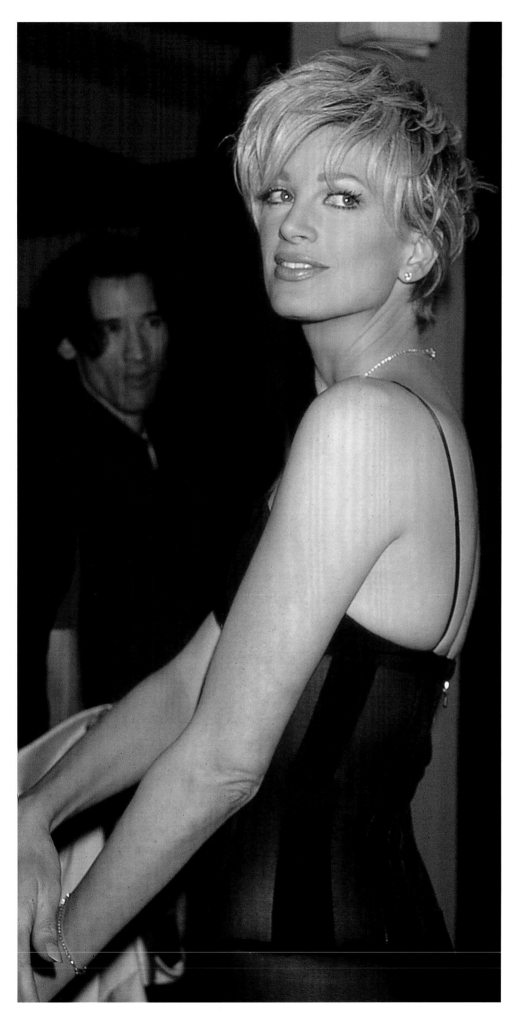

◀ Linda Evangelista, Versace fashion
show, Rock 'n' Rule Benefit after-party,
Park Avenue Armory, New York, 1992

Kristen McMenamy, Helmut Newton
party, Barney's, New York, 1991

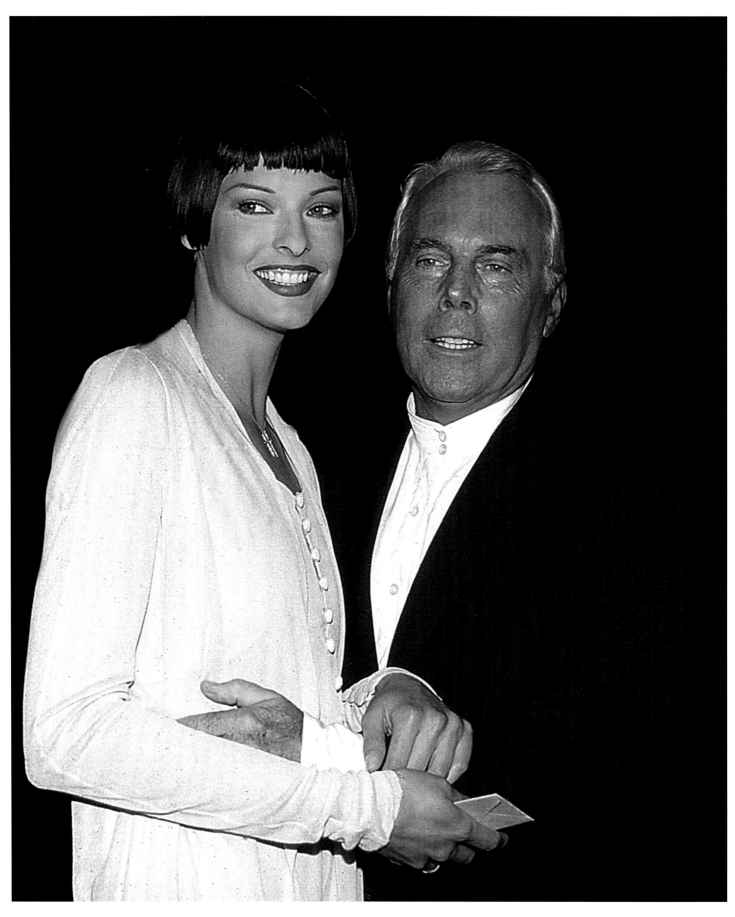

Linda Evangelista, Giorgio Armani's fashion party on West 57th
Street, New York, 1997

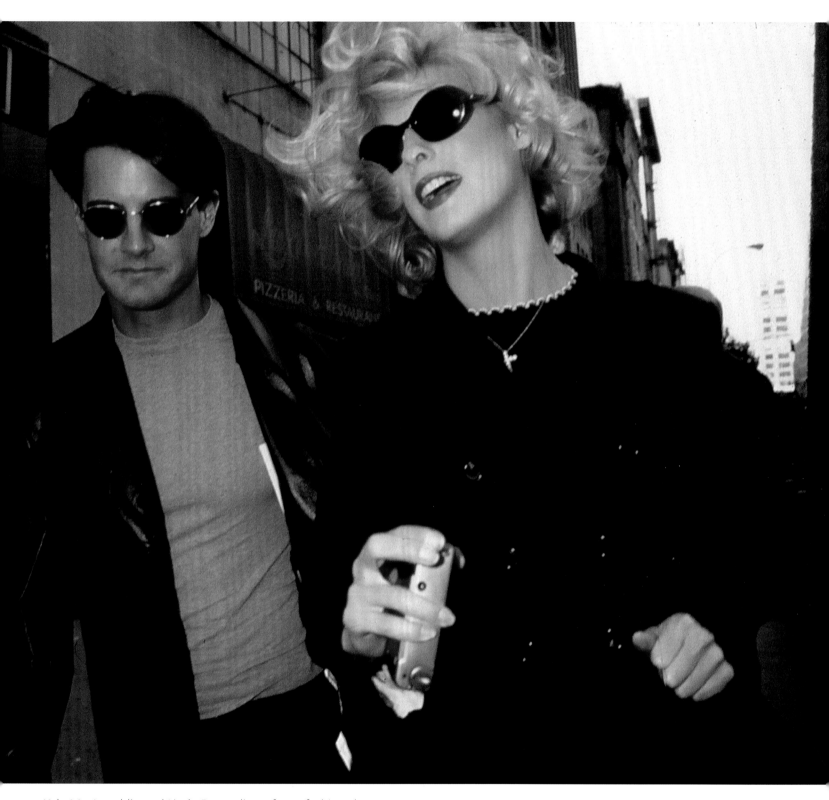

Kyle MacLaughlin and Linda Evangelista after a fashion show,
Hudson Street, New York, 1993

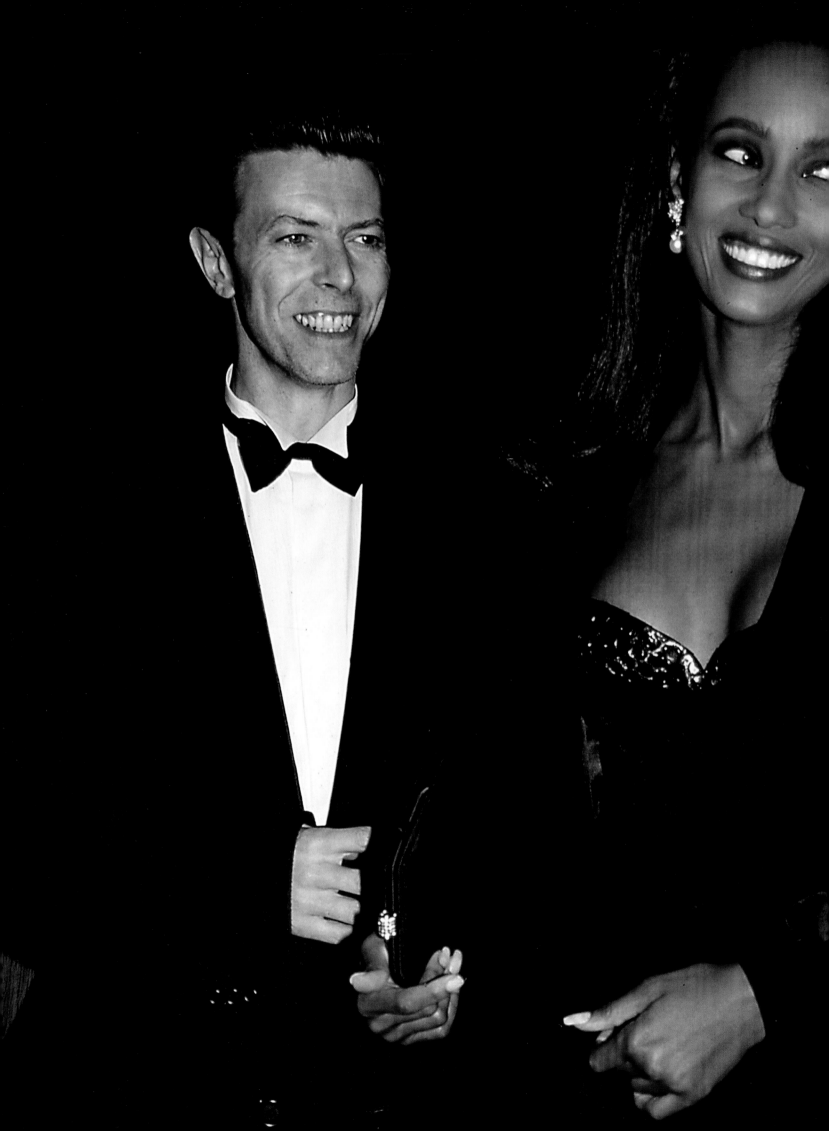

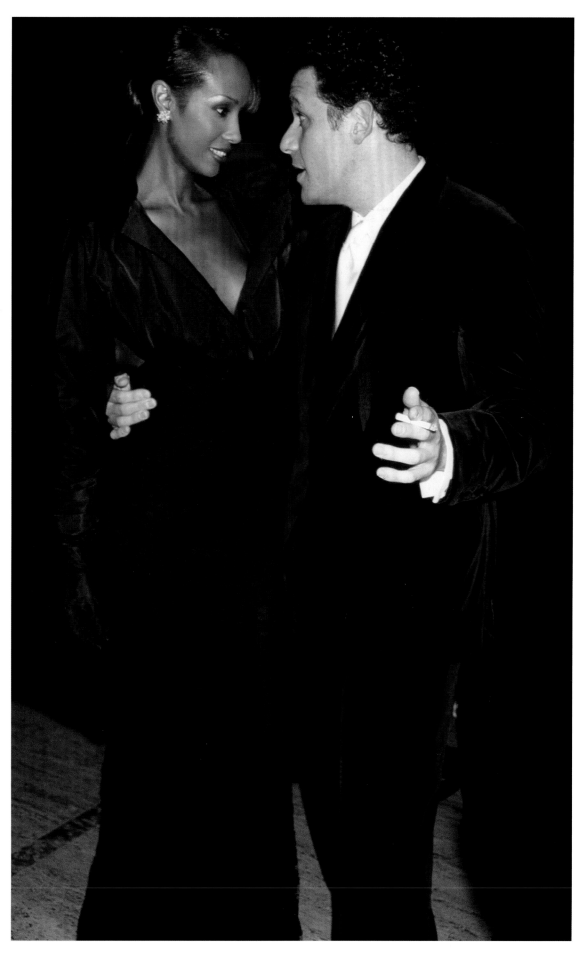

◄ David Bowie and Iman outside a theater, New York, 1992

Iman and Isaac Mizrahi, New York City Ballet Gala, 1999

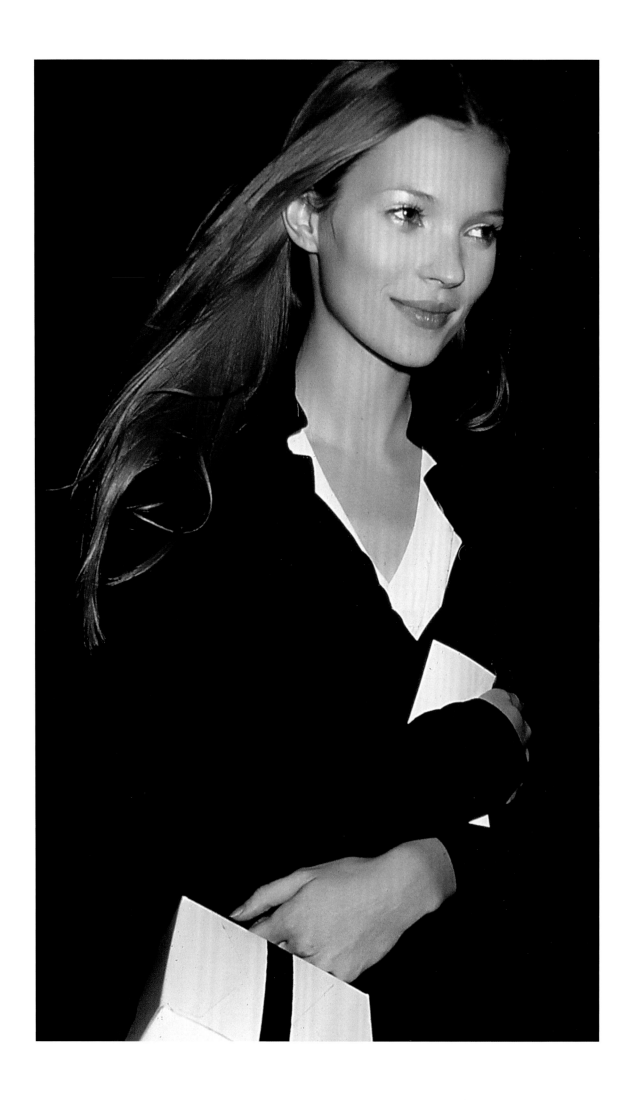

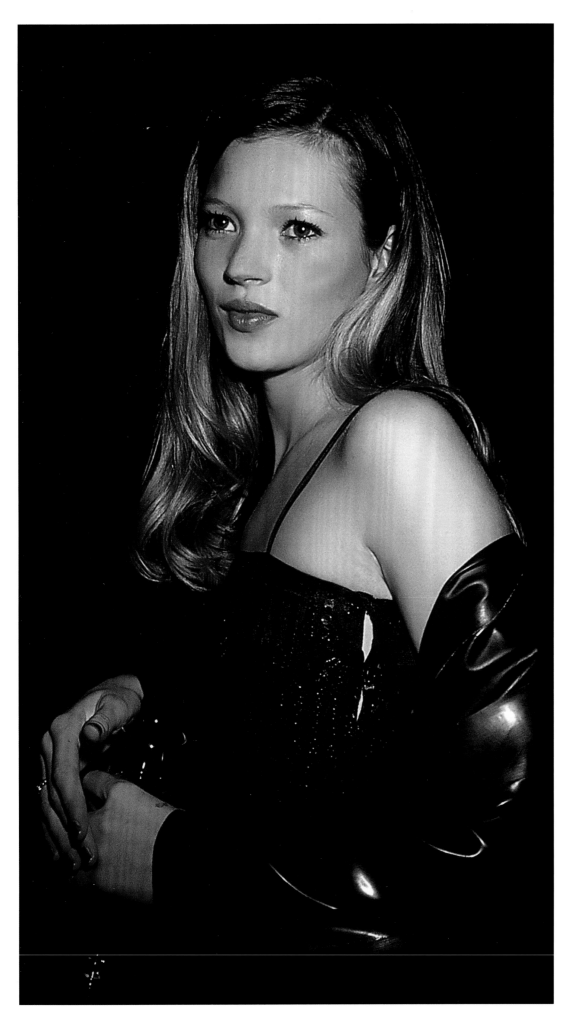

◀ Kate Moss, Fashion Week,
Bryant Park, New York, 1995

Kate Moss, Council of
Fashion Designers of
America Awards, Lincoln
Center, New York, 1994

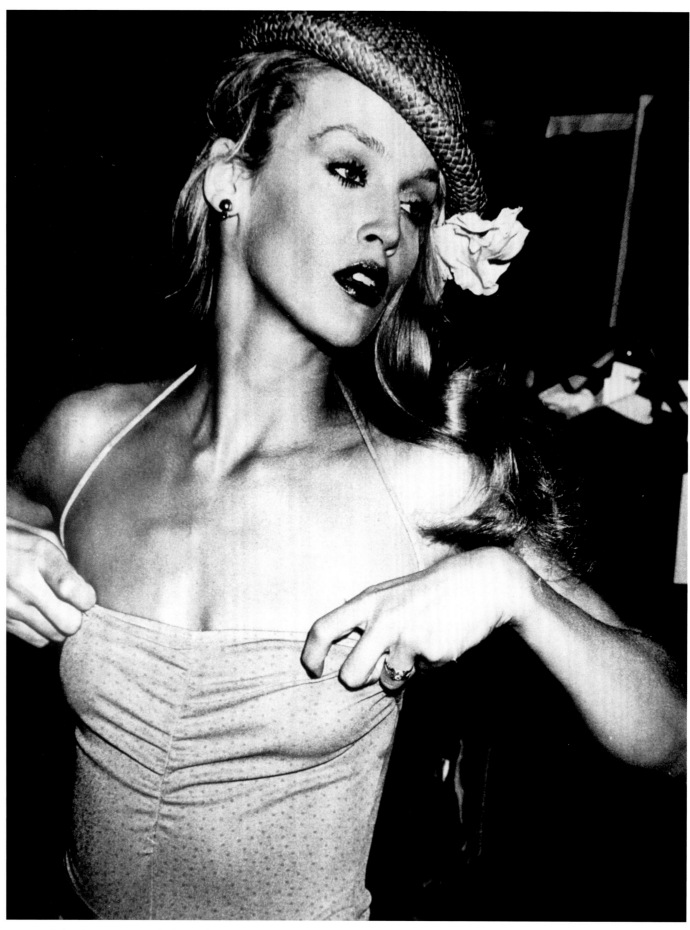

Jerry Hall, backstage, Krizia fashion show, Olympic Towers,
New York, 1979

▸ Grace Jones, Studio 54, New York, 1978

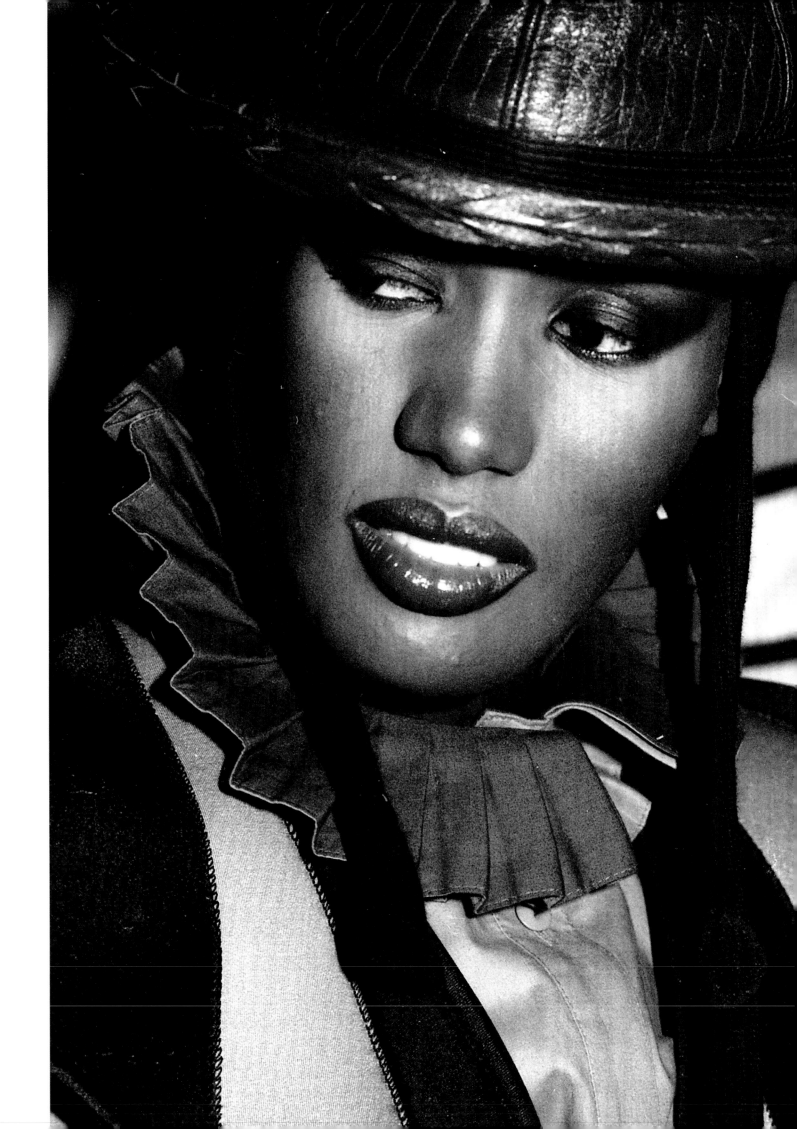

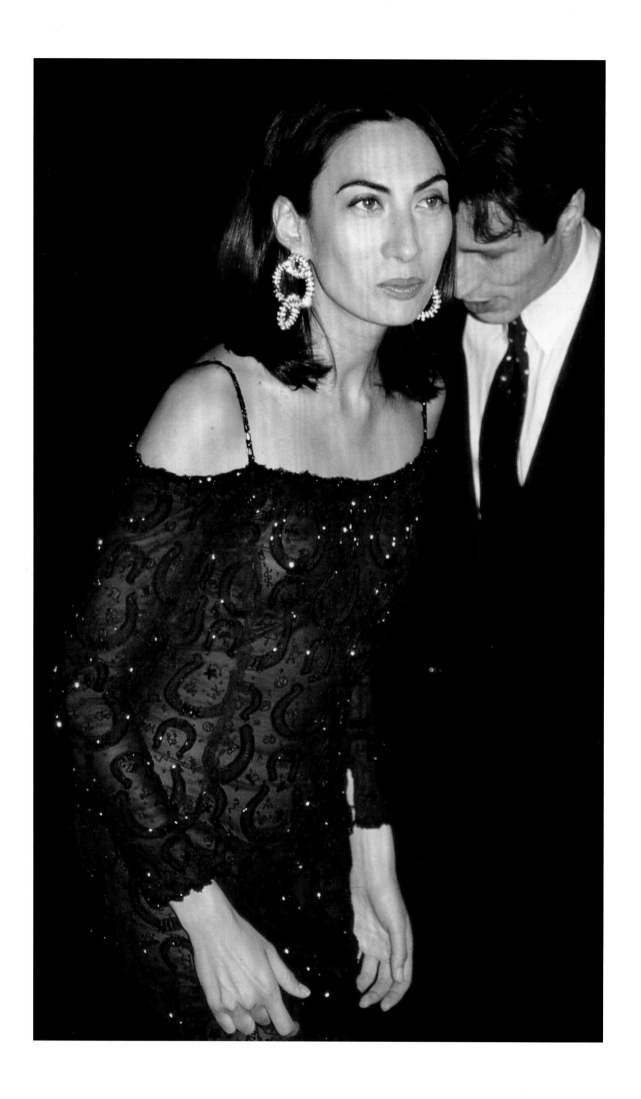

◄ Anh Duong, Council of
Fashion Designers of
America Gala,
New York, 1988

Marisa Berenson, cocktail
party at Harry Winston
Jewelers, New York, 1984

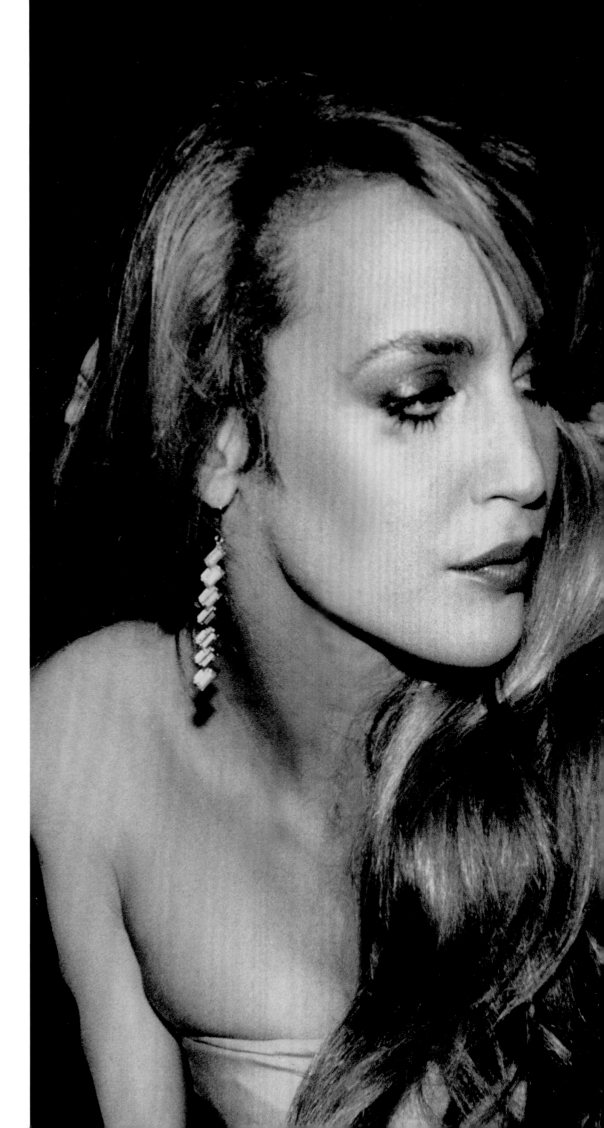

Jerry Hall and Andy Warhol,
Interview magazine party at
Studio 54, New York, 1978

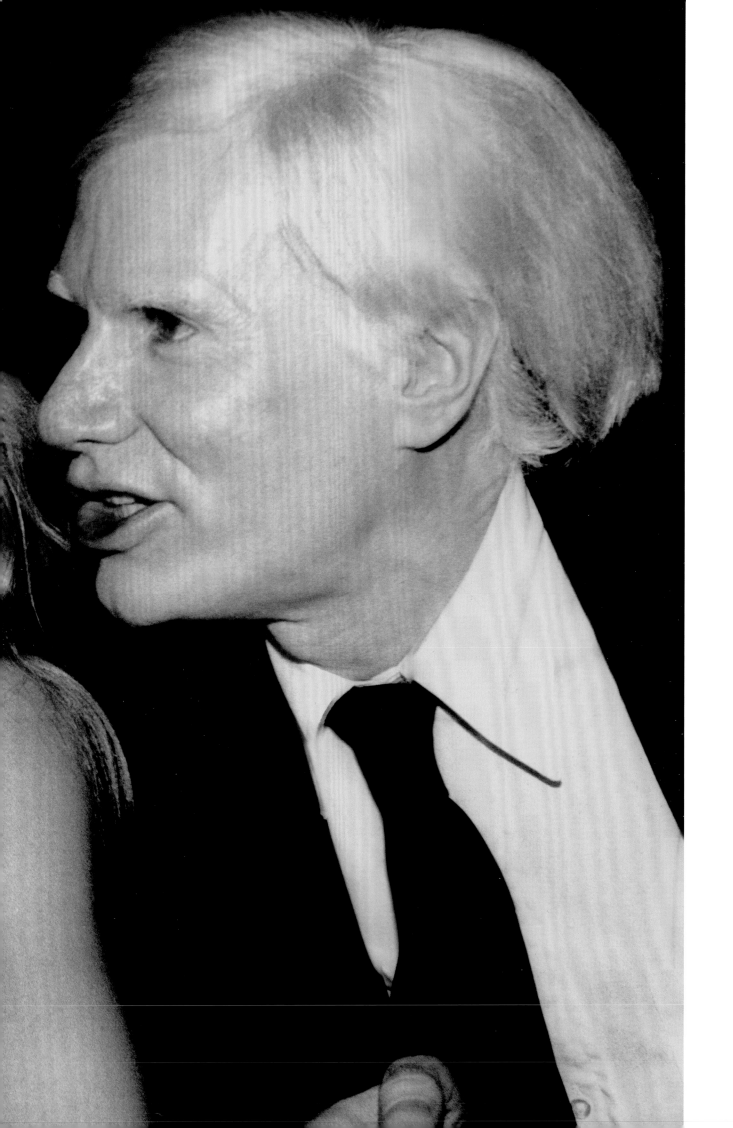

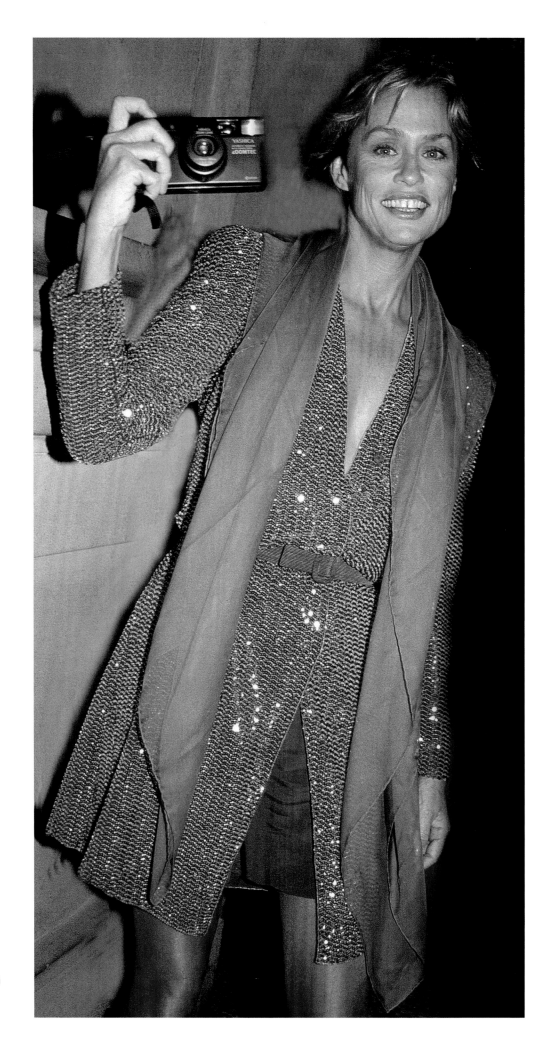

Lauren Hutton, Costume Institute Gala, Metropolitan Museum of Art, New York, 1991

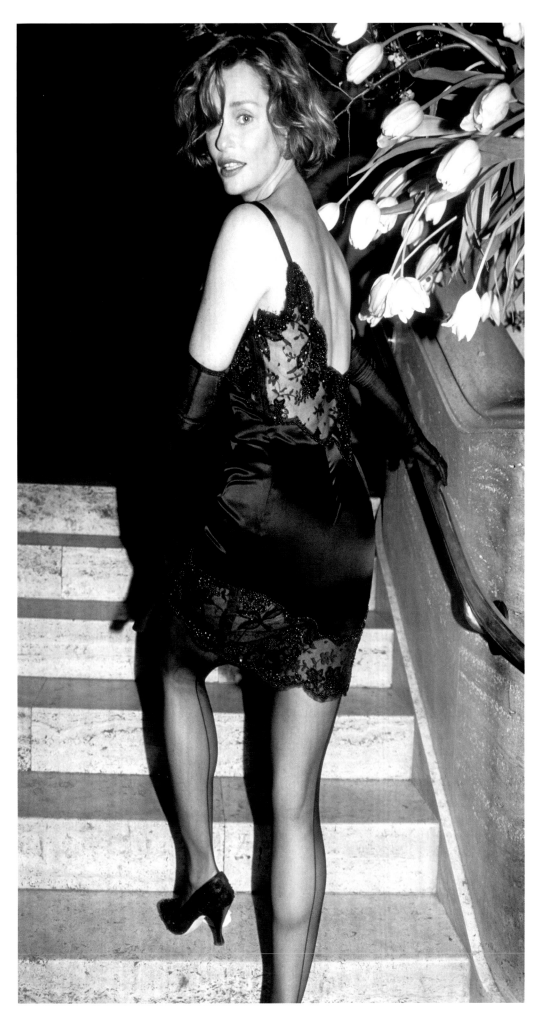

Lauren Hutton, New York
City Ballet Gala, 1999

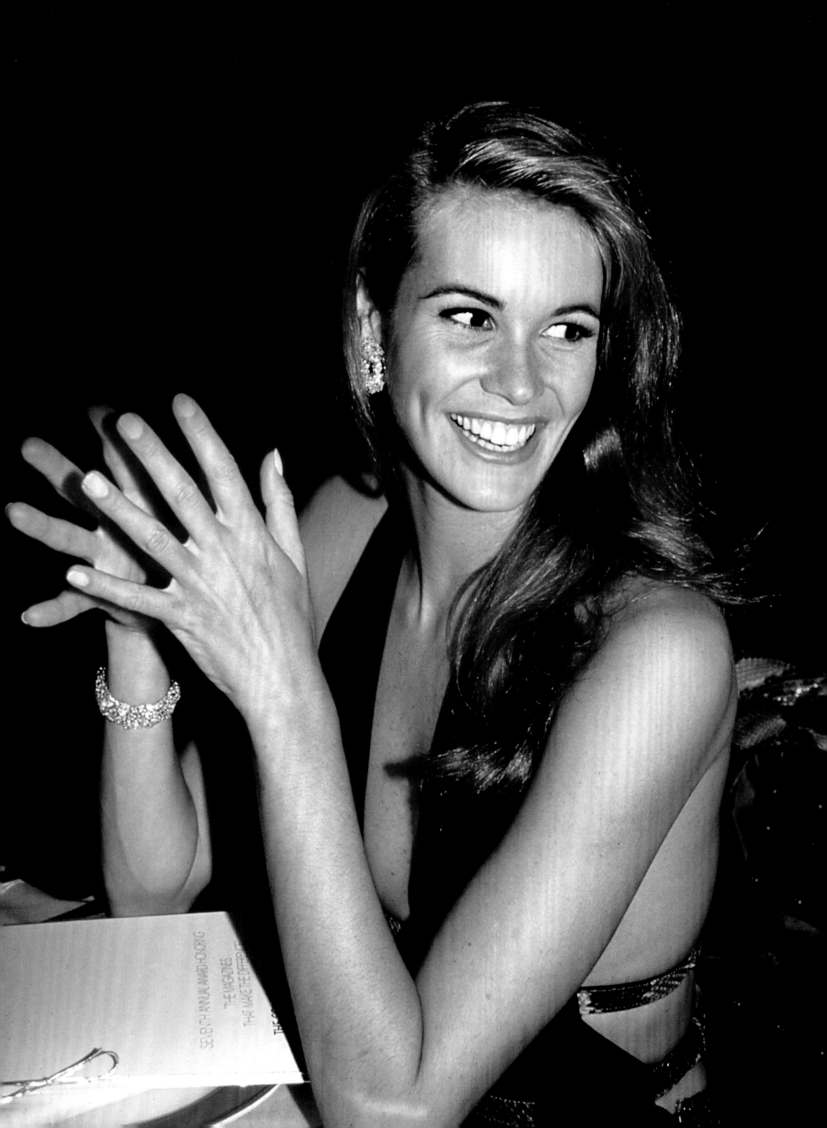

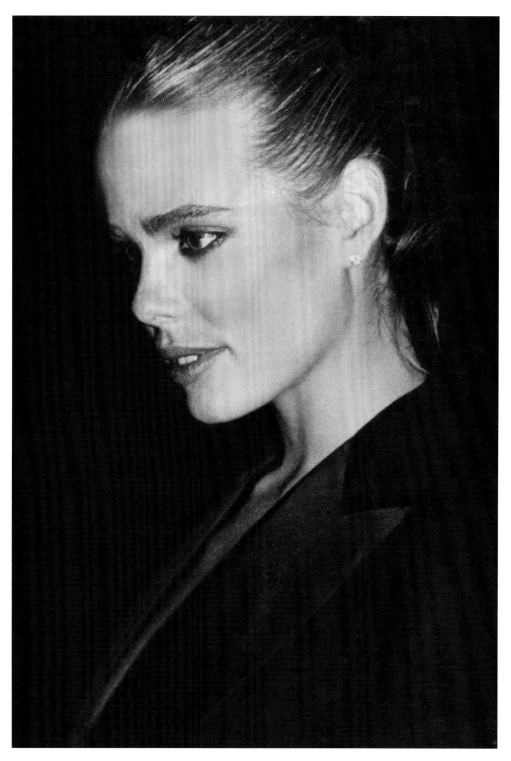

◀ Elle Macpherson, Gala, Waldorf Astoria, New York, circa early 1990s

Margaux Hemingway, Studio 54, New York, 1979

◀ Anh Duong, Vikram Chatwal, Council of Fashion Designers of America, Lincoln Center, New York, 2000

James Truman and Nadja Auermann, Costume Institute Gala, Metropolitan Museum of Art, New York, 1994

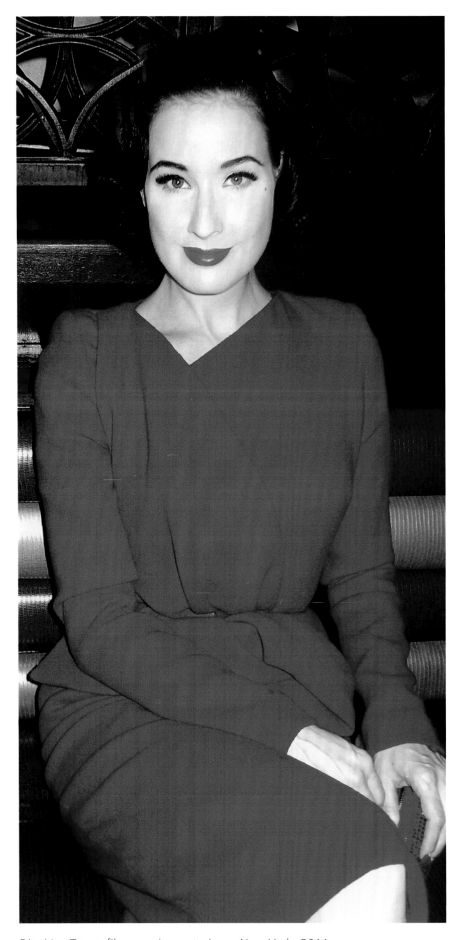

Dita Von Teese, film premier party, Lavo, New York, 2011

▶ Carla Bruni, Galliano fashion show, Bergdorf Goodman
Penthouse, New York, 1995

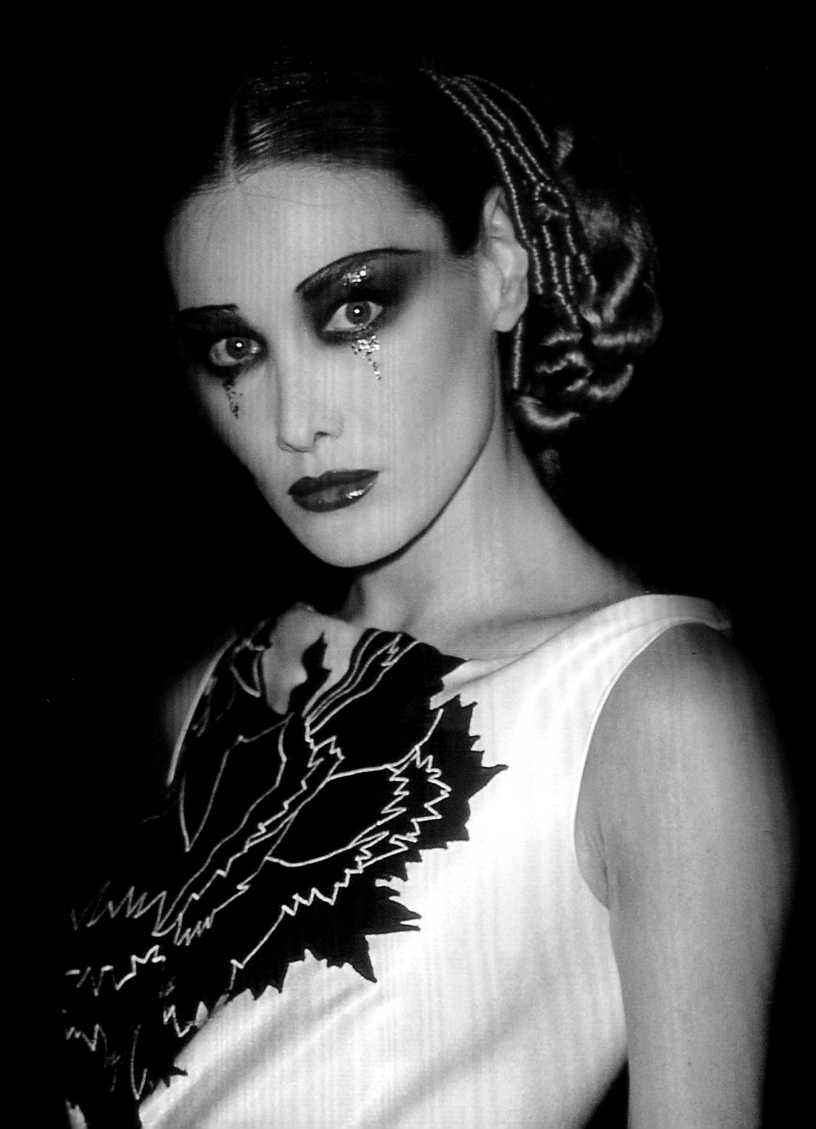

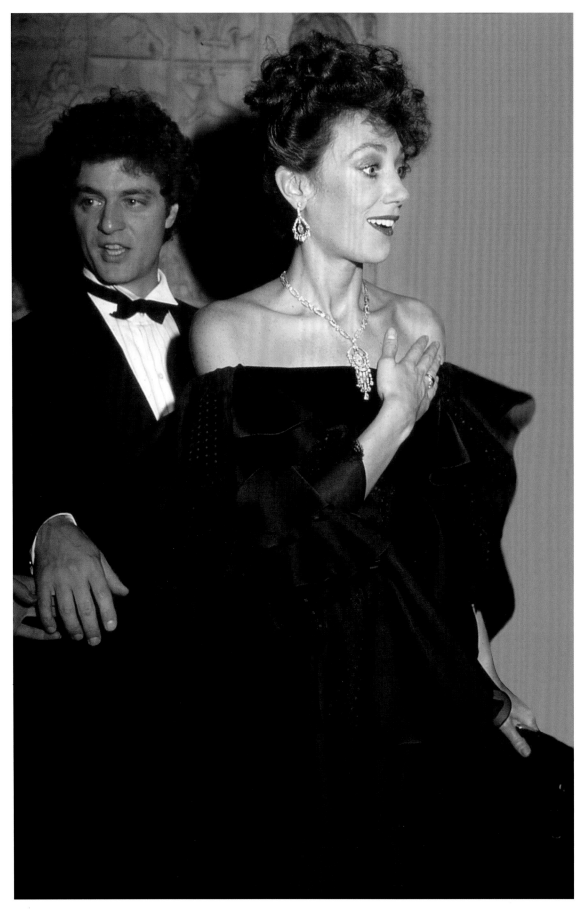

Richard Golub and Marisa Berenson, Costume Institute Gala,
Metropolitan Museum of Art, New York, 1994

▶ Carmen Dell'Orifice, fashion party at Bergdorf Goodman,
New York, early 1990s

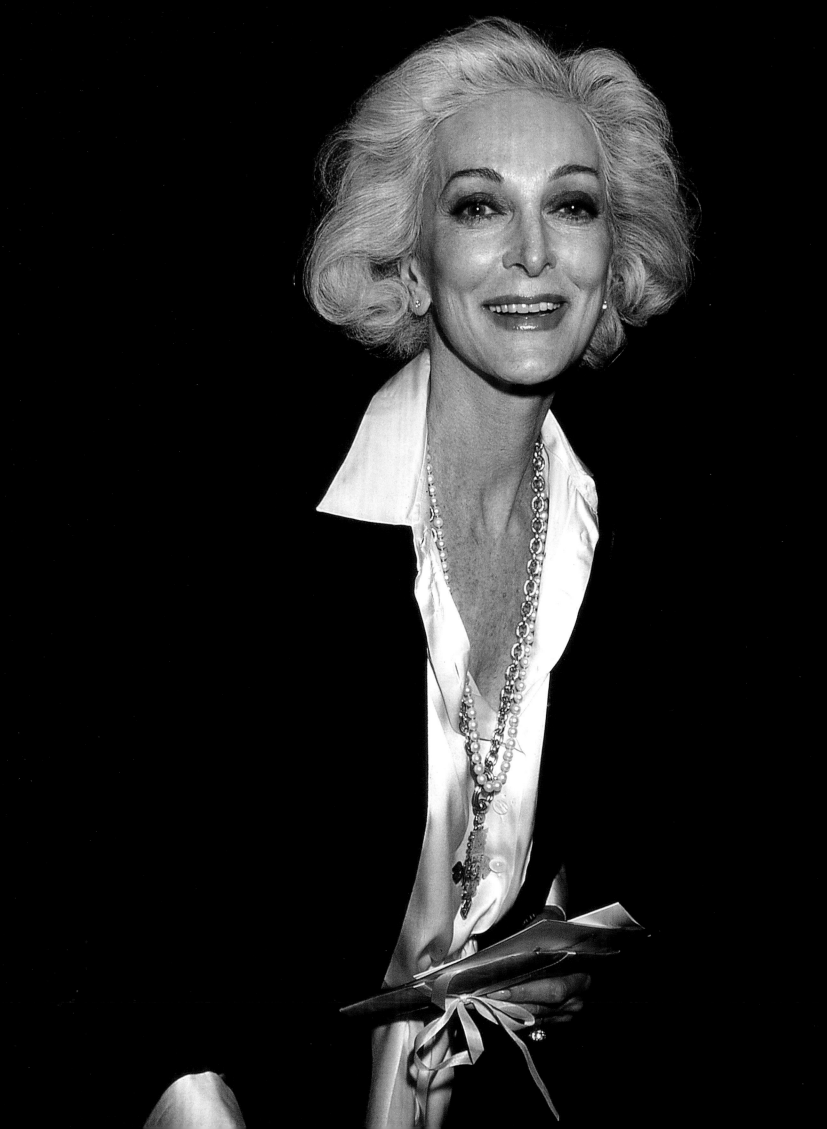

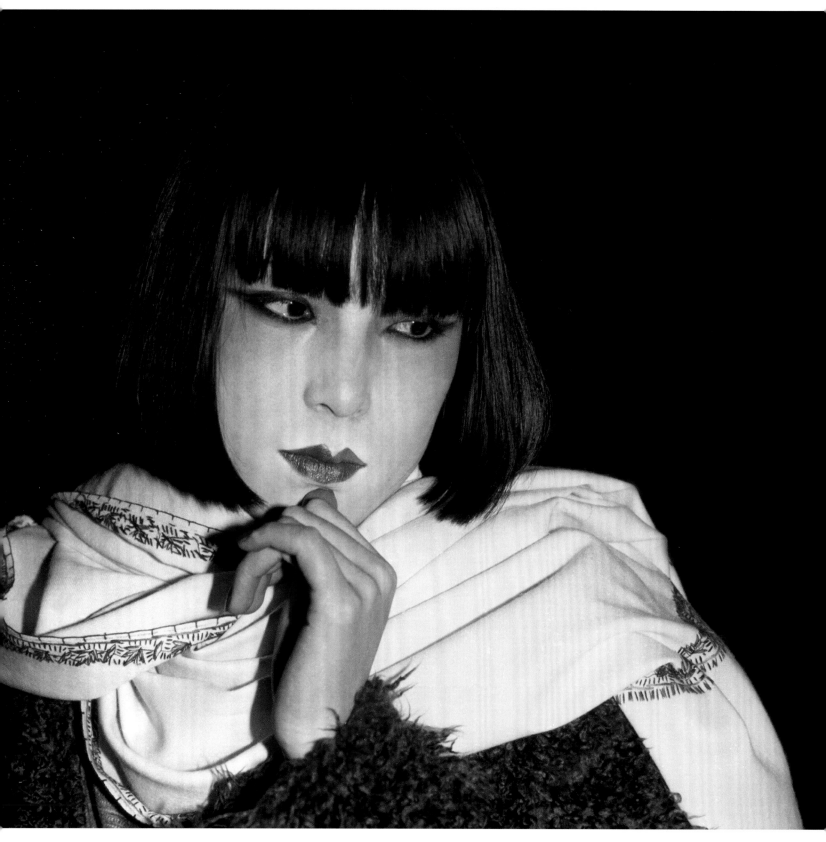

Toko Yamasaki, Roseland Ballroom, New York, 1980

▸ Agyness Deyn, Stephen Sprouse retrospective, Deitch Projects,
Soho, New York, 2009

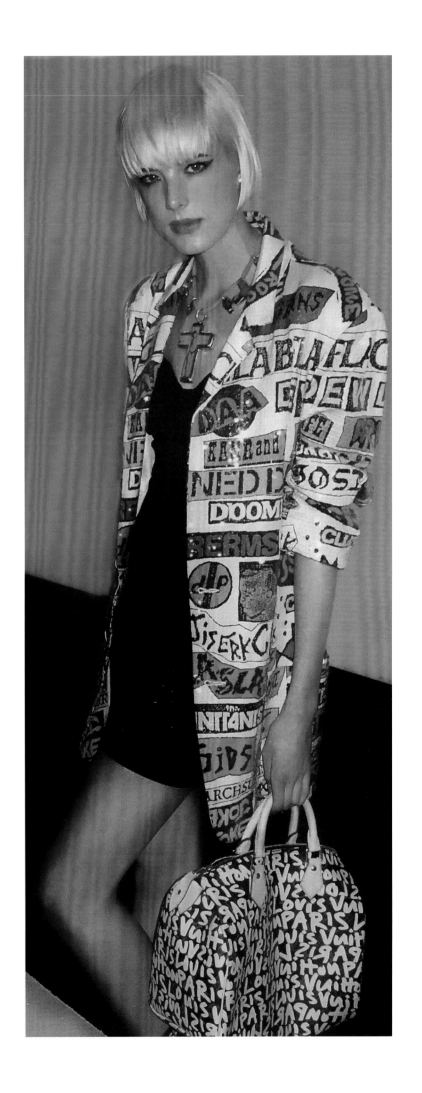

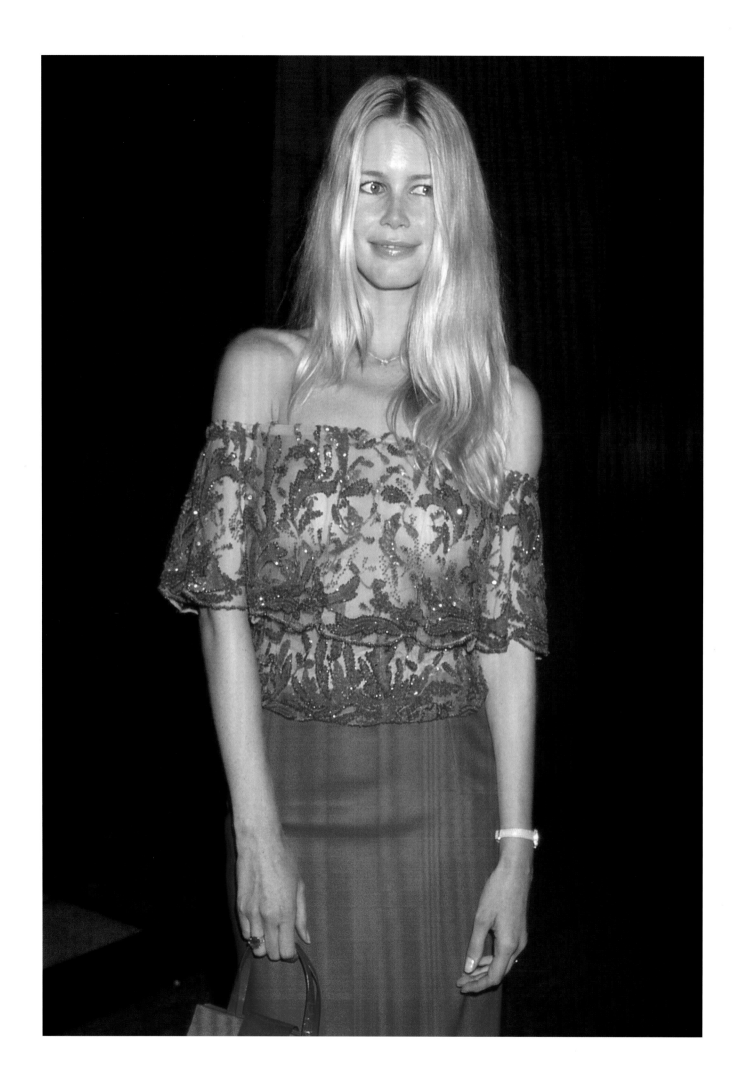

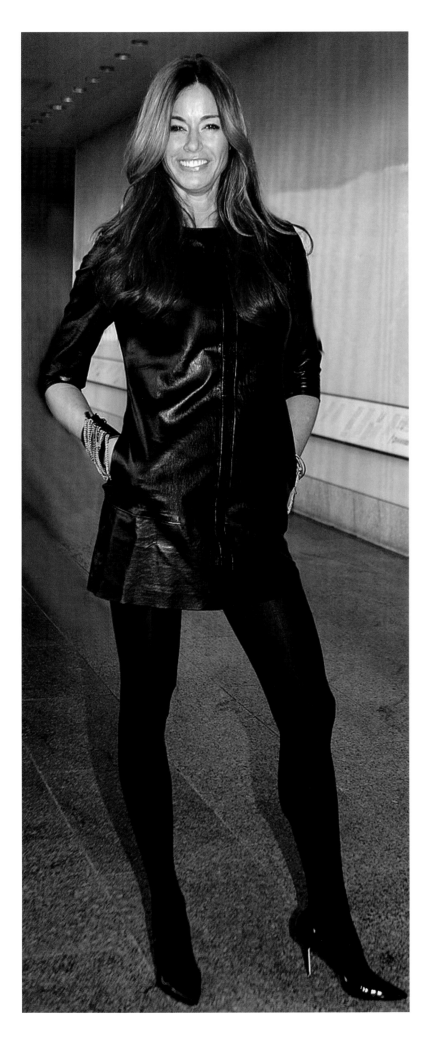

◀ Claudia Schiffer, Valentino
dinner, Four Seasons
restaurant, New York, 2000

Kelly Bensimon, luncheon to
celebrate models of the
1973 Versailles Fashion
Show, Metropolitan Museum
of Art, New York, 2011

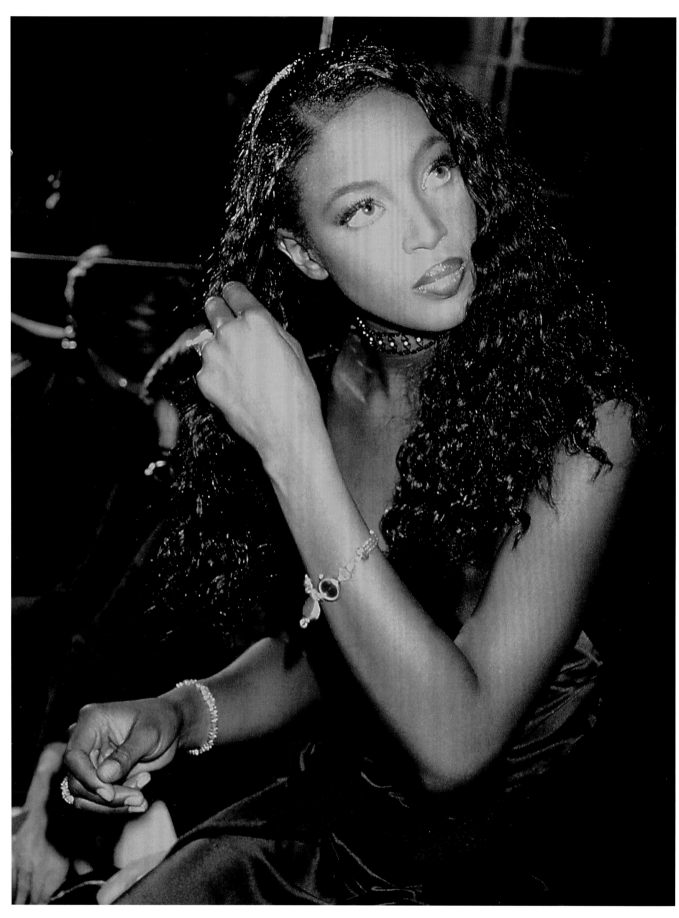

Naomi Campbell, Victoria's Secret fashion show, Plaza Hotel,
New York, early 1990s

▶ Christy Turlington, Costume Institute Gala, Metropolitan Museum
of Art, New York, 1992

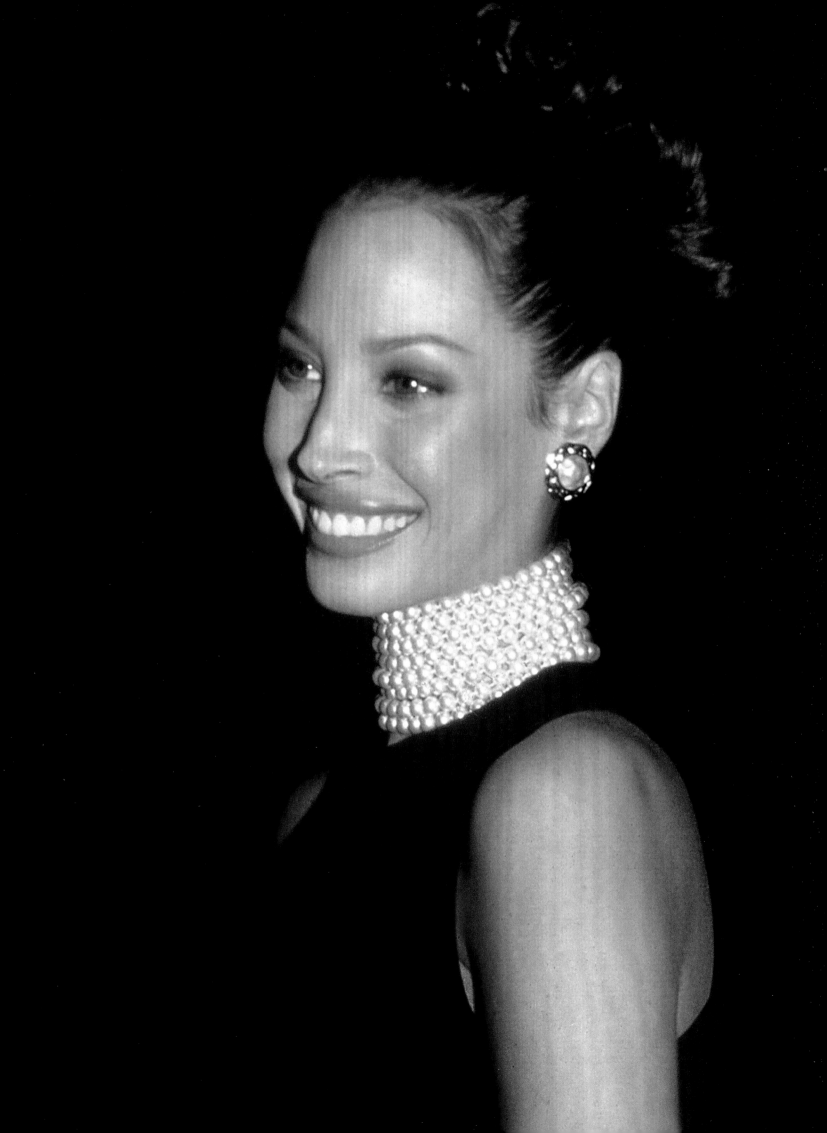

Betsy Johnson
Backstage

DESIGNERS

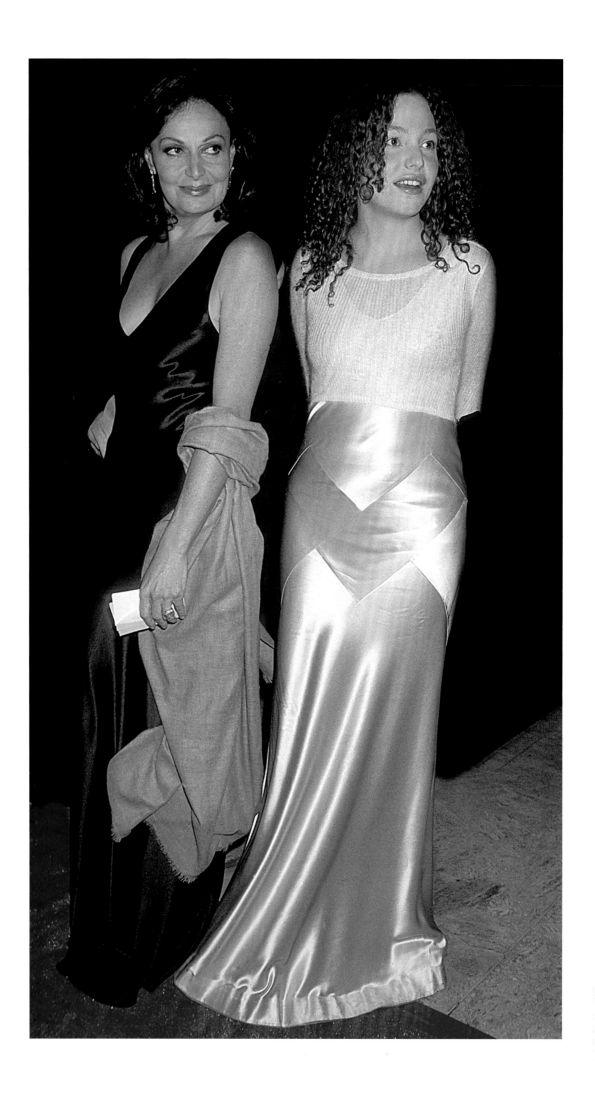

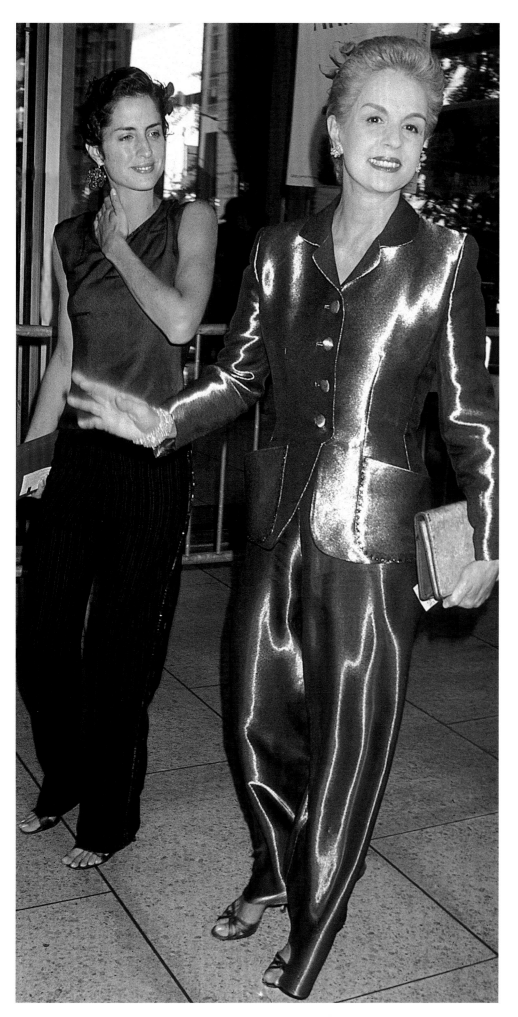

◀ Diane and Tatiana Von Furstenberg,
New York Ballet Gala, Lincoln Center,
New York, 1992

Anna and Carolina Herrera, Lincoln
Center, New York, circa 1990s

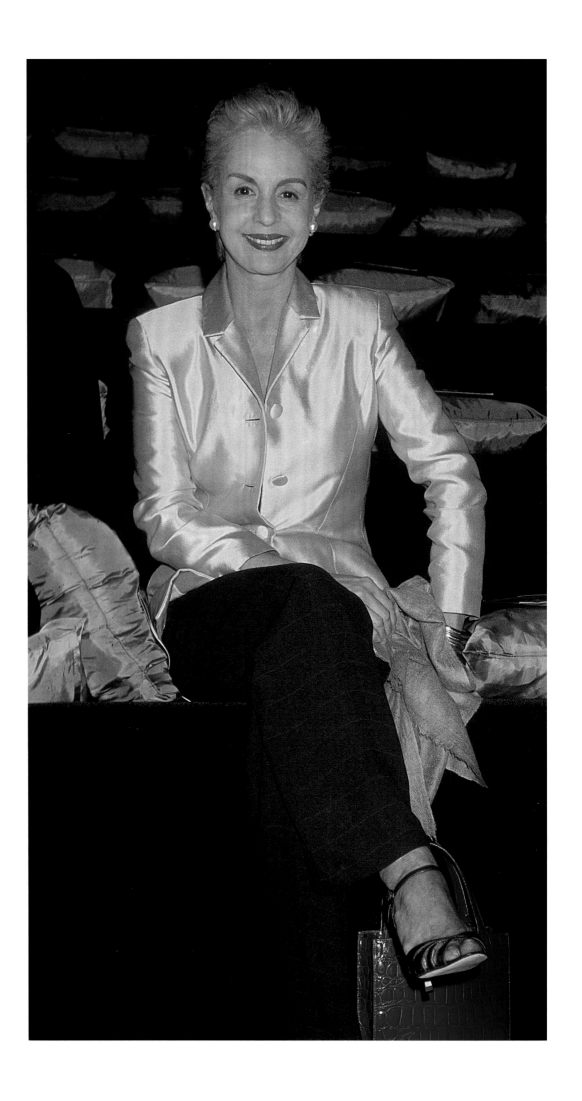

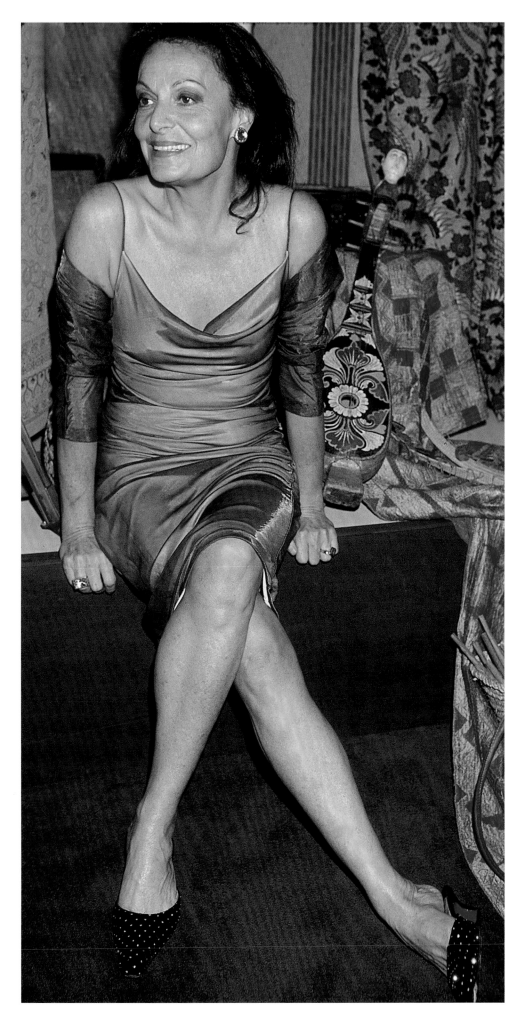

◄ Carolina Herrera, fashion show,
Bryant Part, New York, 2002

Diane Von Furstenberg in her West
Village loft, New York, 2002

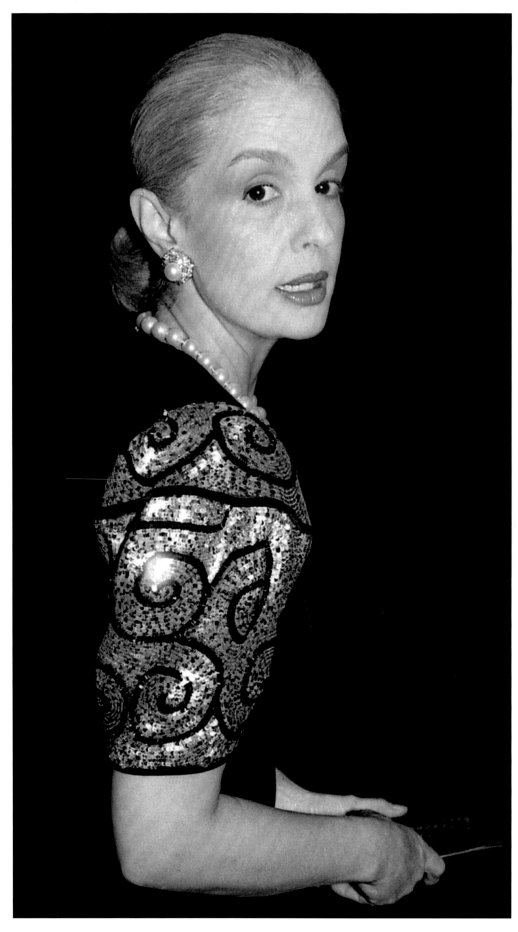

Carolina Herrera, Gala, Plaza Hotel, New York, 1995

▶ Paloma Picasso, Costume Institute Gala, Metropolitan Museum
of Art, New York, 1984

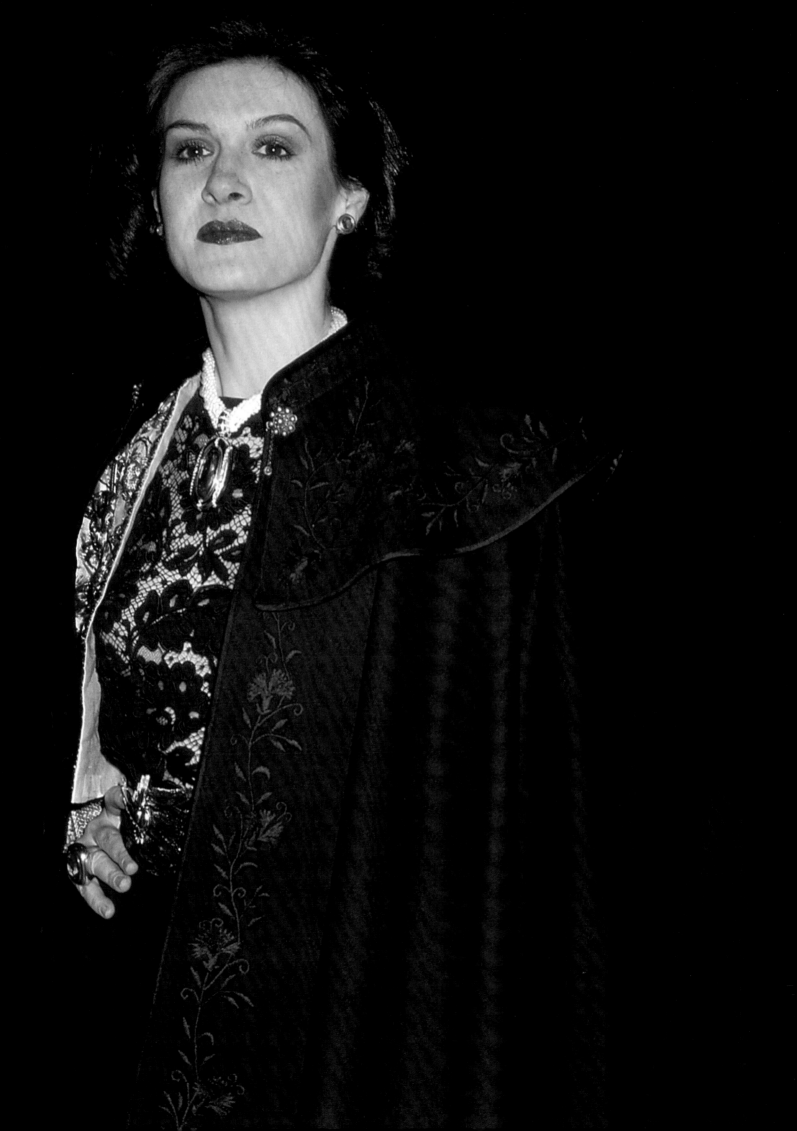

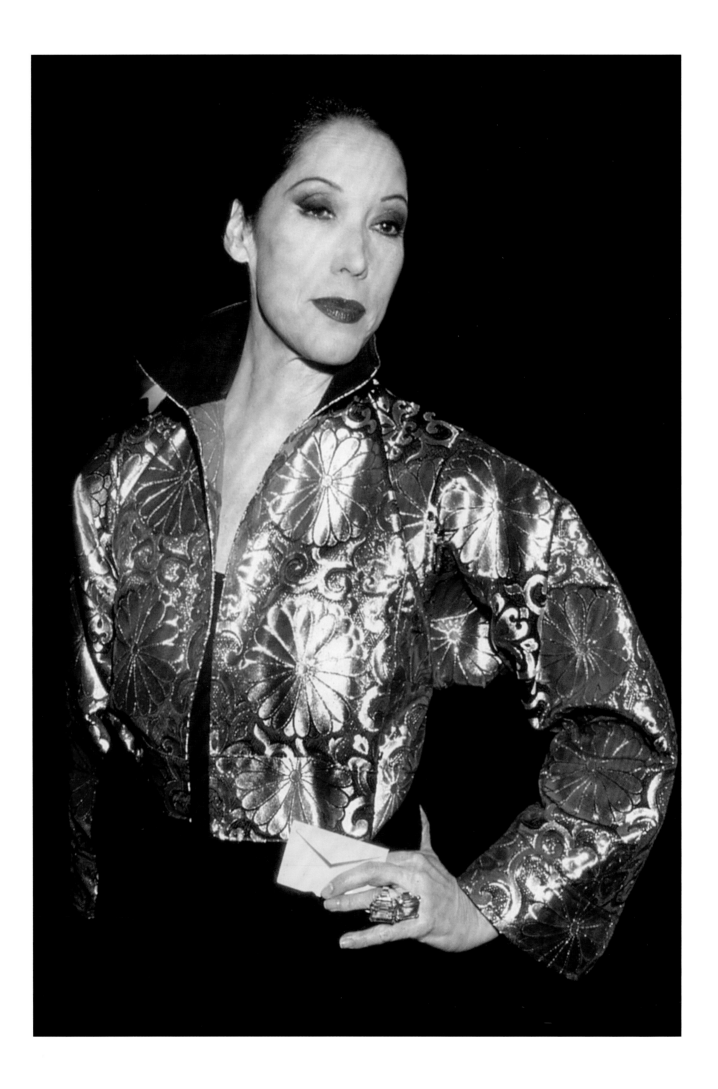

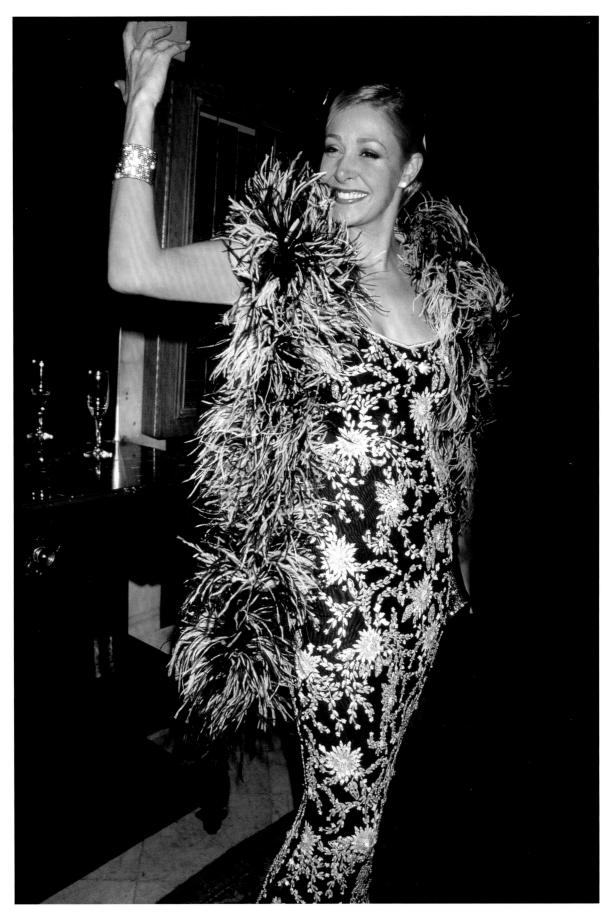

◂ Marima Schiano, Costume Institute Gala, Metropolitan
Museum of Art, New York, 1997

Nadja Swarovski, cocktail party, Swarovski boutique, New York,
2007

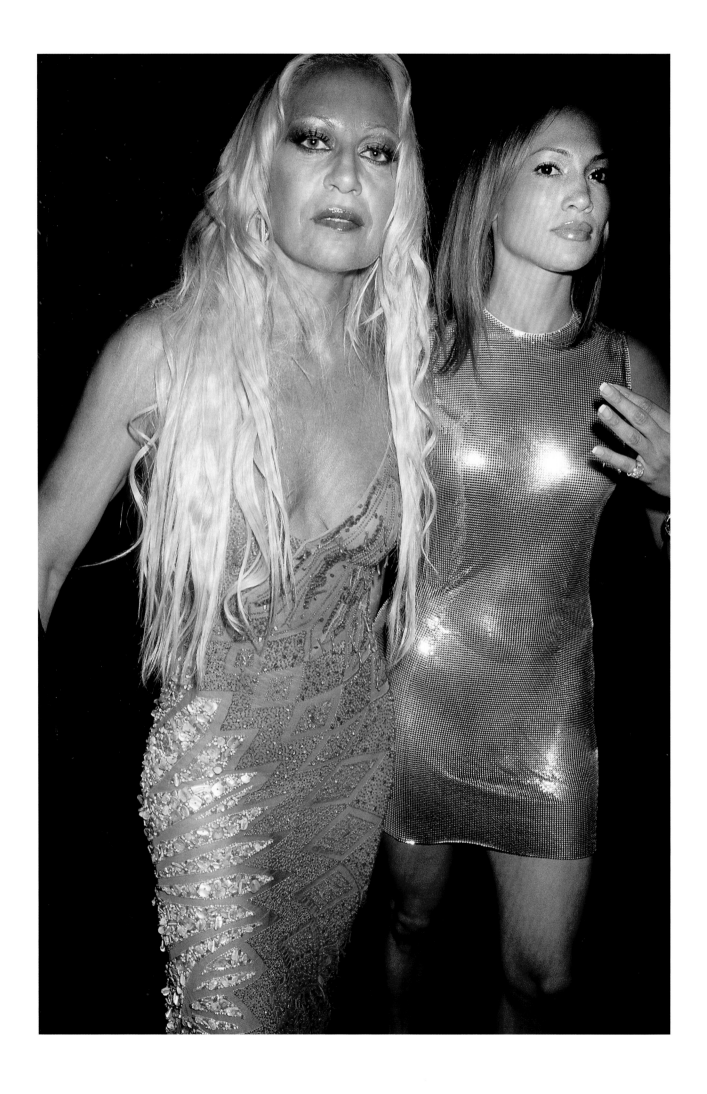

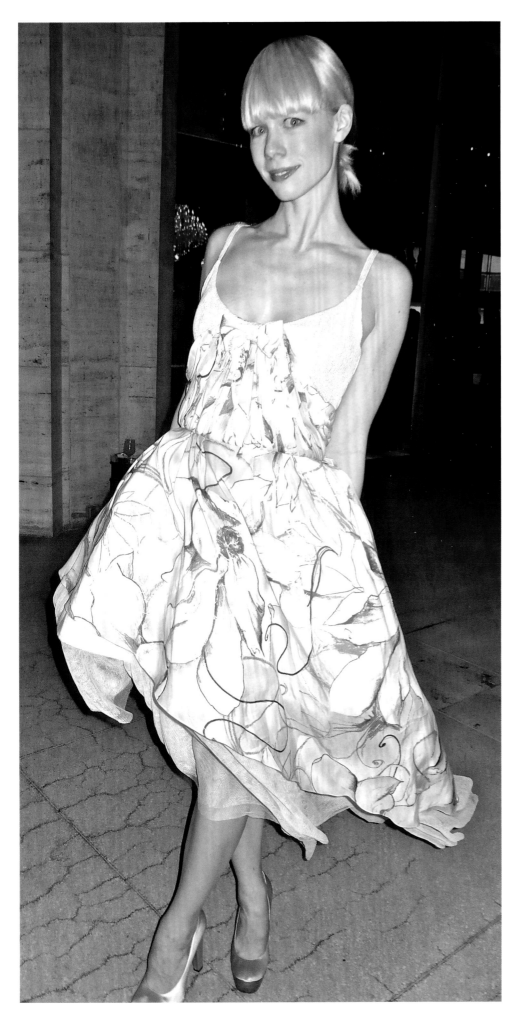

◄ Donatella Versace and Jennifer
Lopez, cocktail party, Limelight,
New York, circa 1990s

Erin Fetherston, New York City Ballet
Gala, Lincoln Center, New York, 2008

Fred Hughes and Elsa Peretti at the Marlboro Gallery, New York,
1979

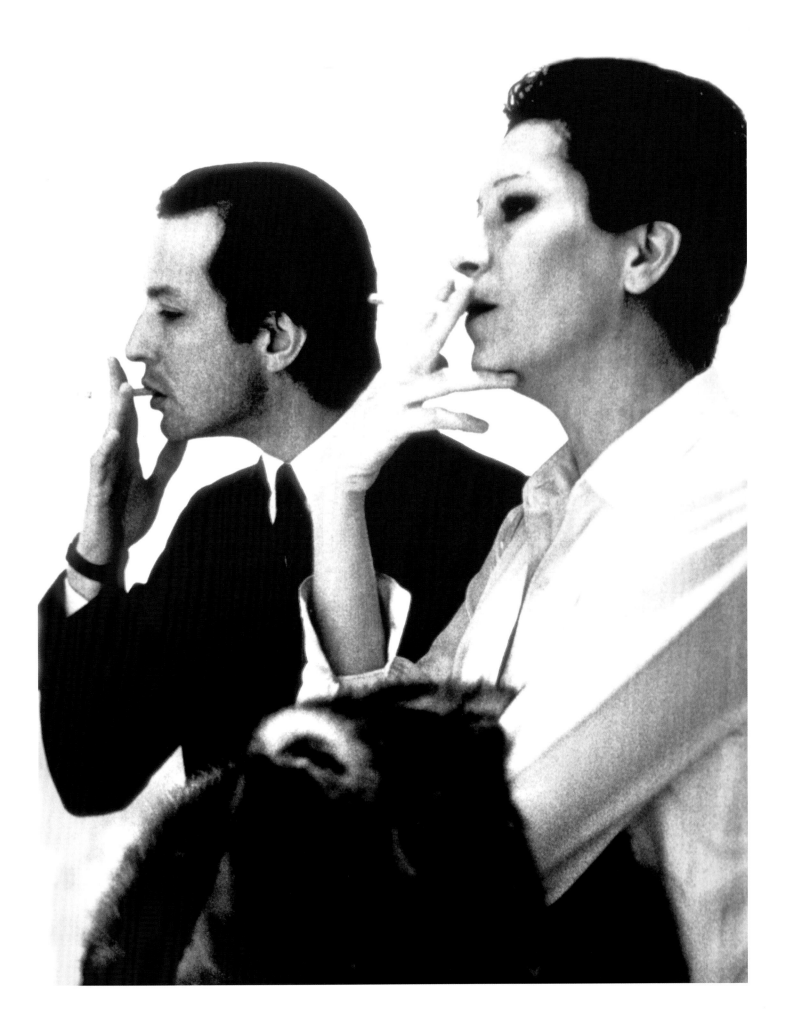

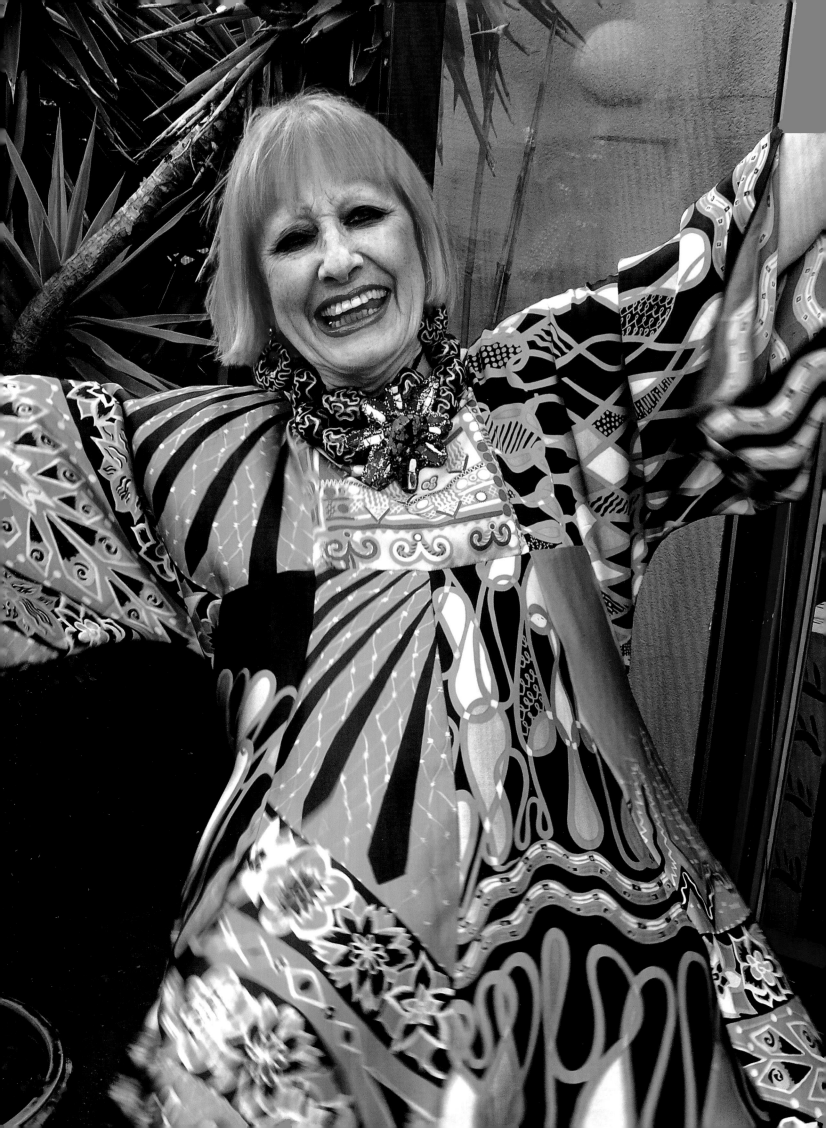

◀ Zandra Rhodes, on her terrace in London's East End, 2011

Vivienne Westwood, 'Night of Stars', Pierre Hotel, New York,
1996

Betsey Johnson, Harley Davidson
party, Soho, New York, early 1990s

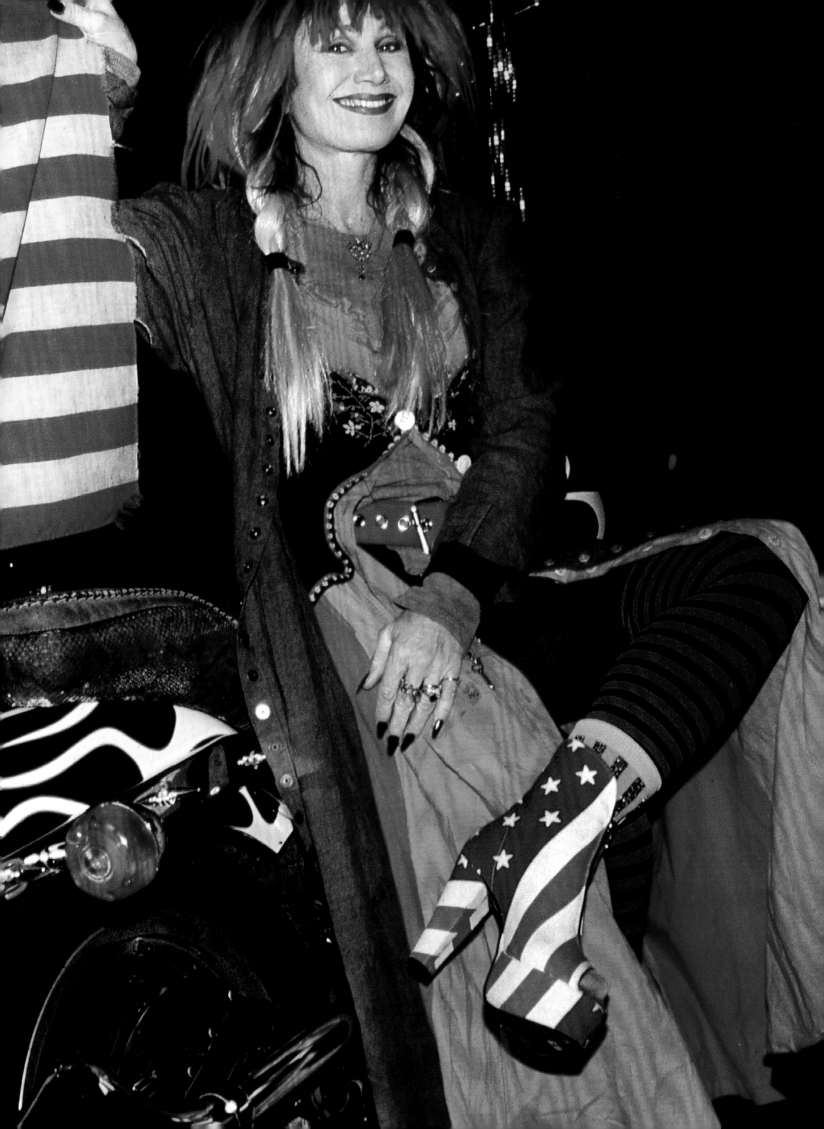

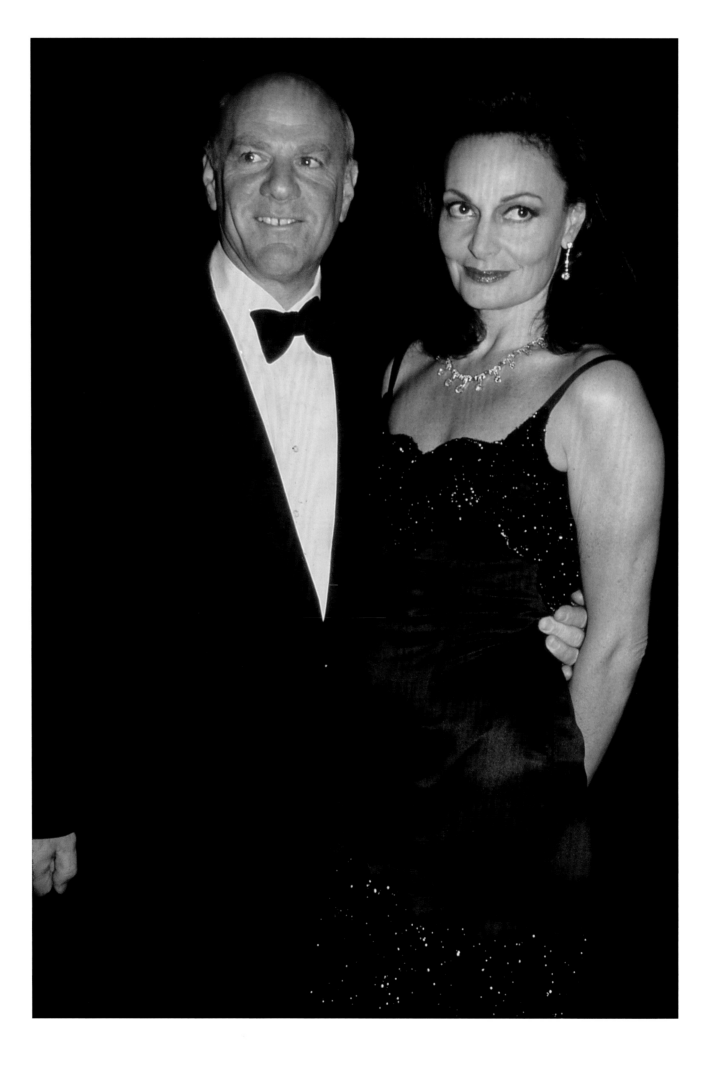

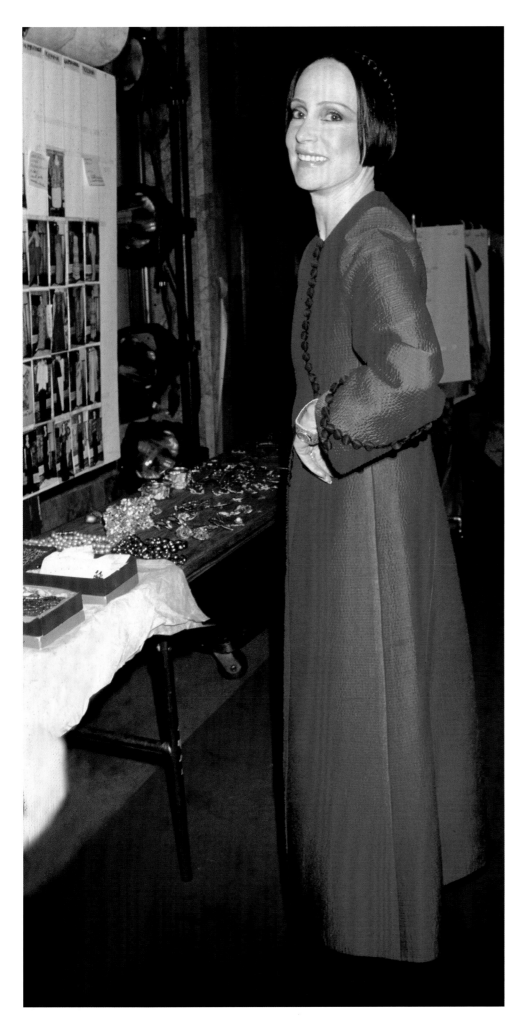

◀ Barry Diller and Diane Von Furstenberg, private dinner party, New York, 2001

Mary McFadden in her West 35th Street design studio, New York, 1998

ACTORS

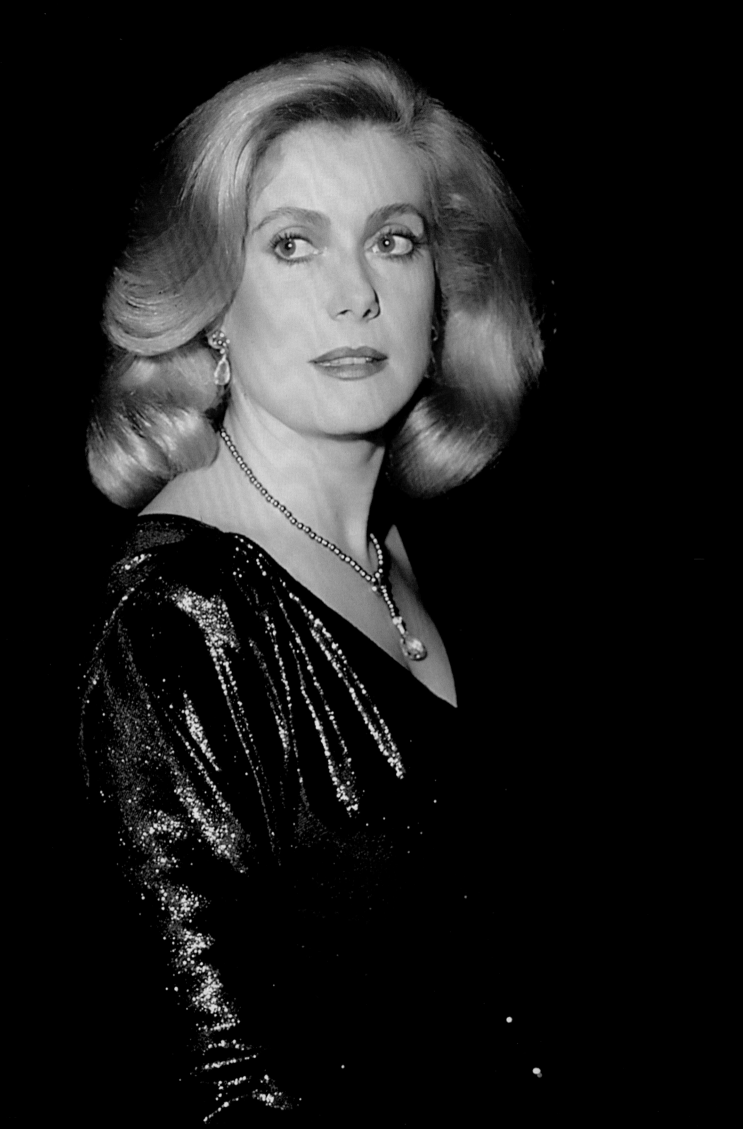

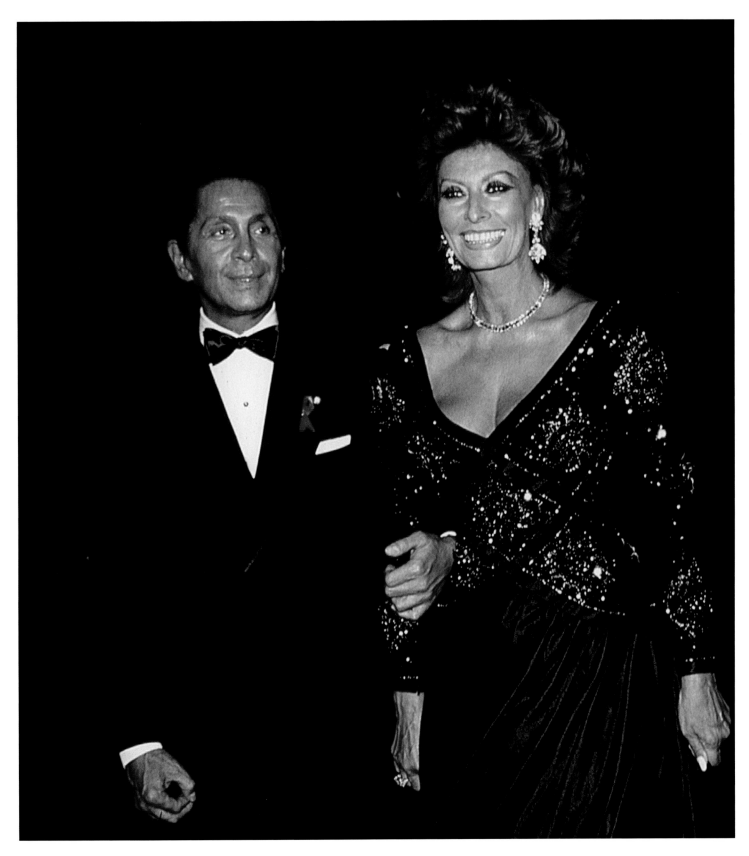

◂ Catherine Deneuve, film party, Museum of Modern Art,
New York, 1996

Valentino and Sophia Loren, Valentino party, Park Avenue Armory,
New York, 1992

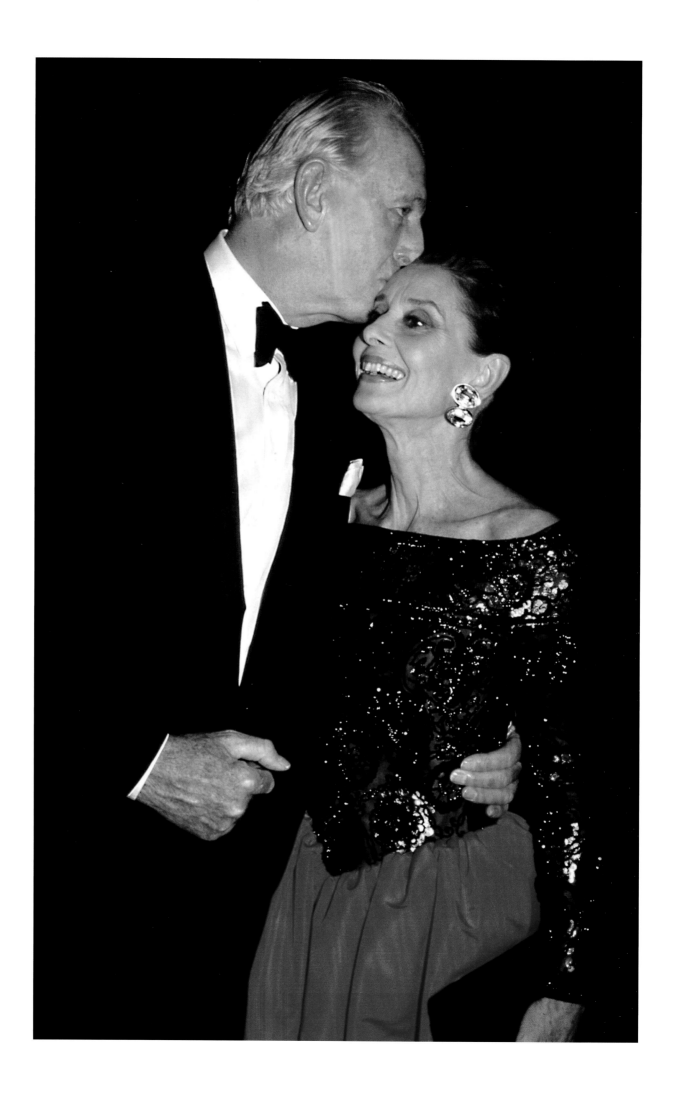

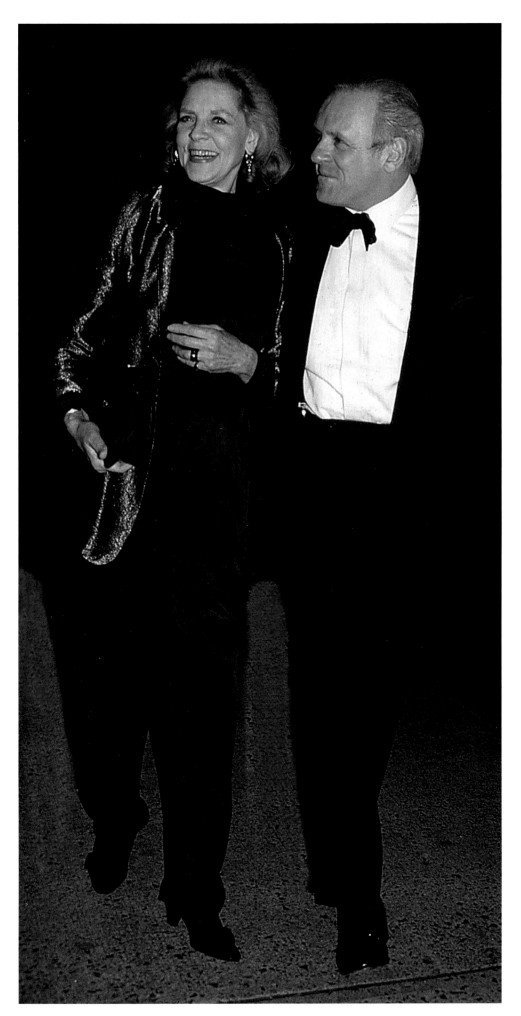

◀ Givenchy and Audrey Hepburn,
'Night of Stars' Gala, Waldorf Astoria,
New York, 1991

Lauren Bacall and Anthony Hopkins,
film premiere, Lincoln Center,
New York, 1996

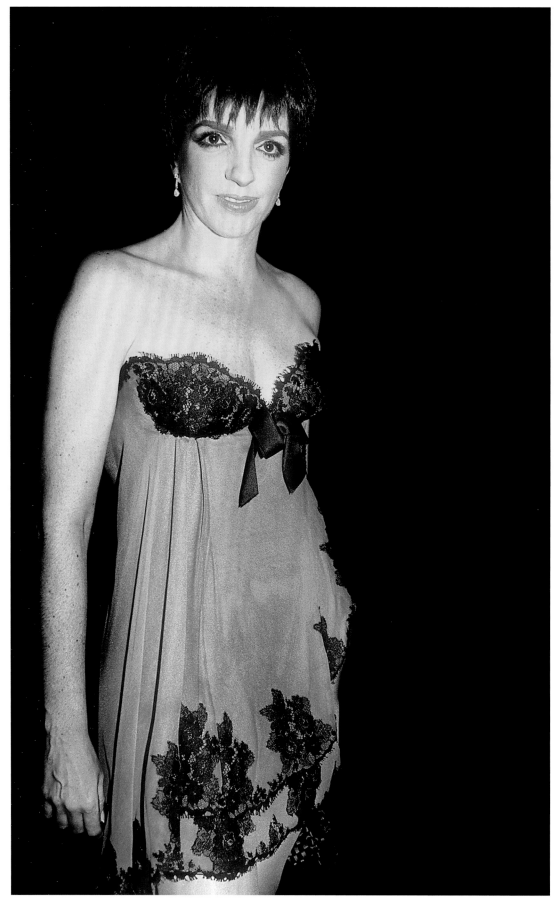

Liza Minnelli at Saks Fifth Avenue party for Oscar de la Renta,
New York, 1982

▸ Sienna Miller, Vogue-hosted film party, Museum of Modern Art,
New York, 2007

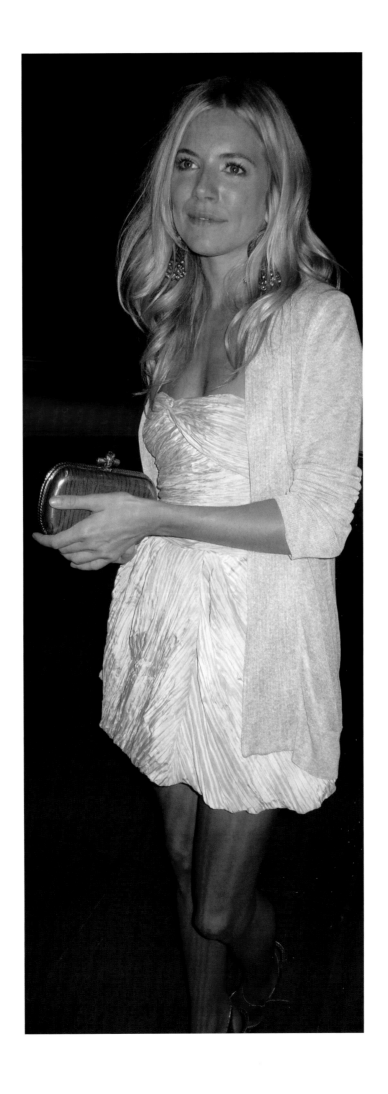

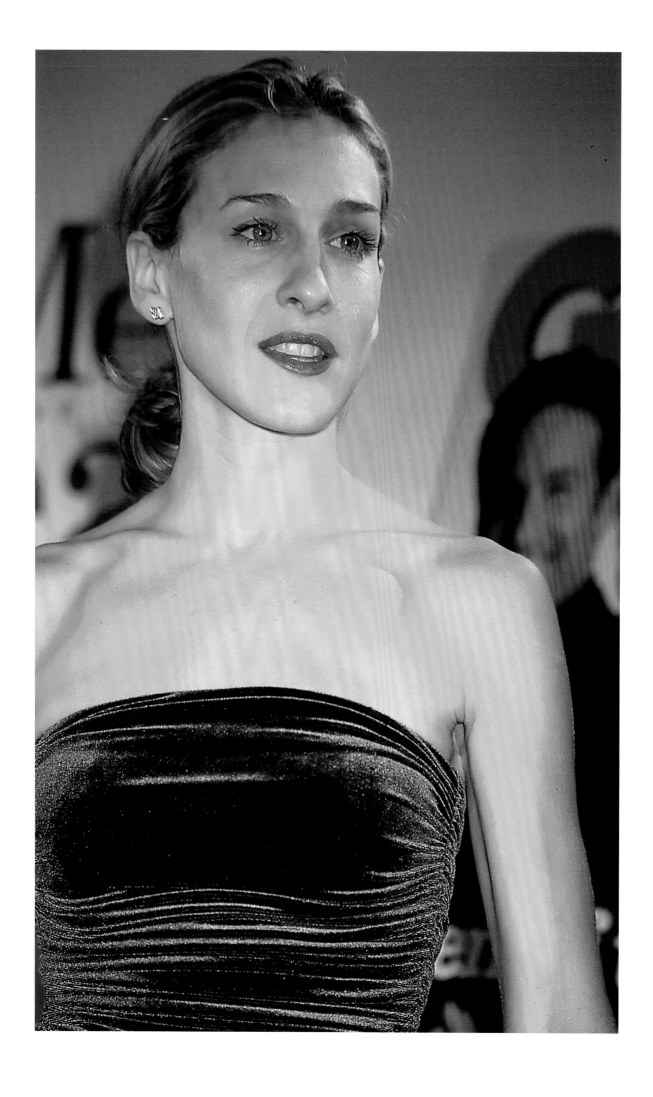

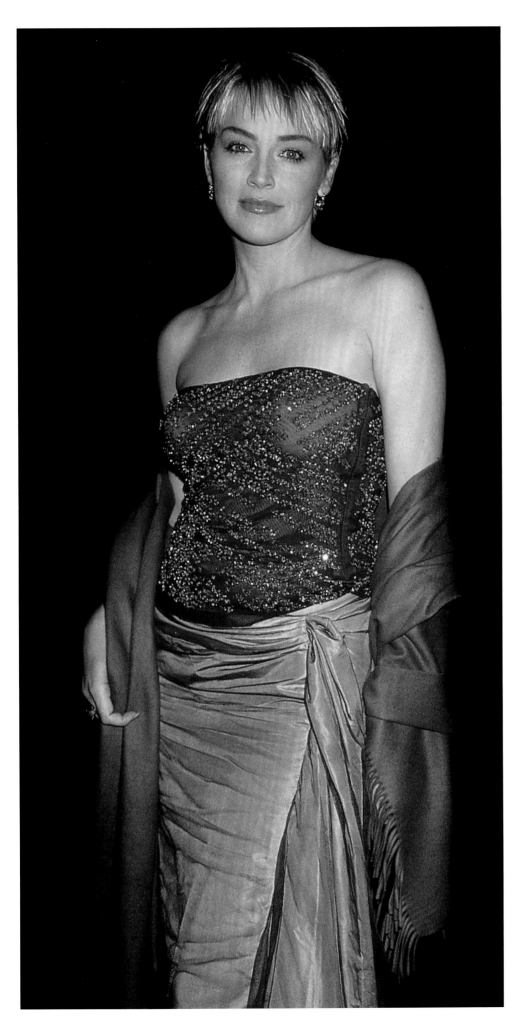

◀ Sarah Jessica Parker, GQ Awards,
Radio City Music Hall, New York,
circa 1990s

Sharon Stone, New York City Ballet
Gala, Lincoln Center, New York, 1995

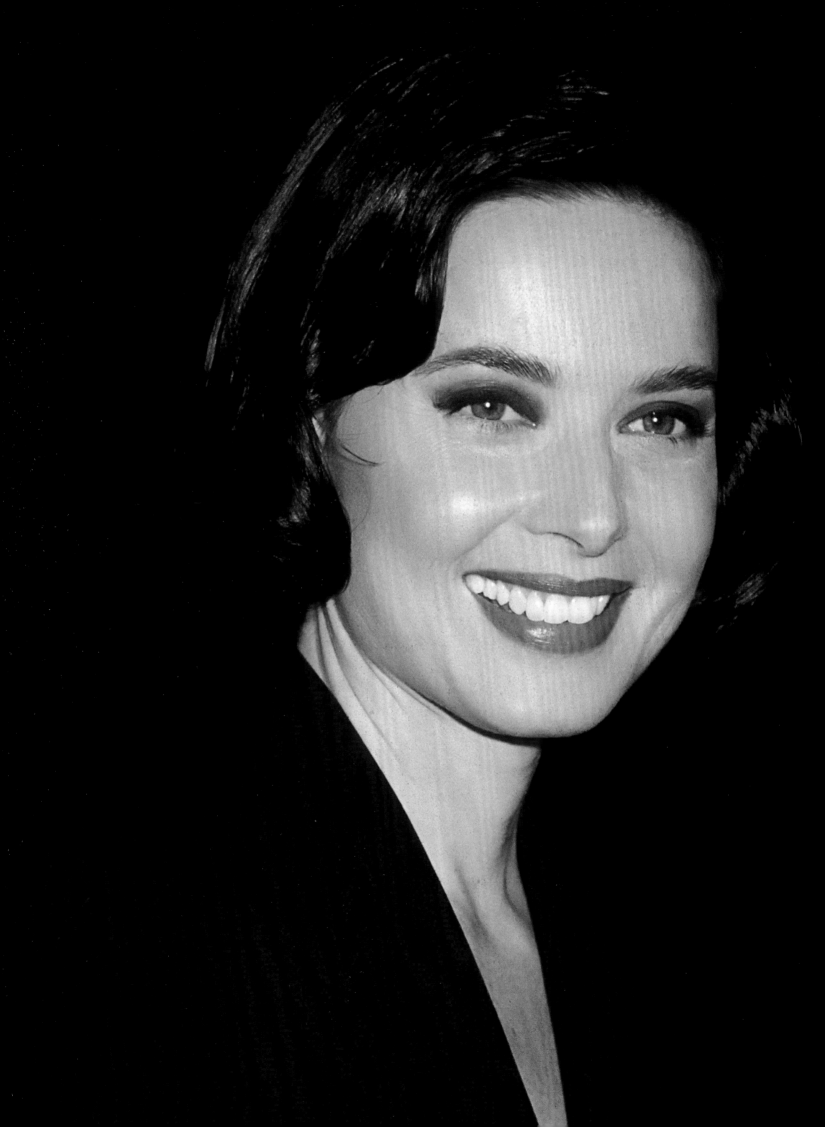

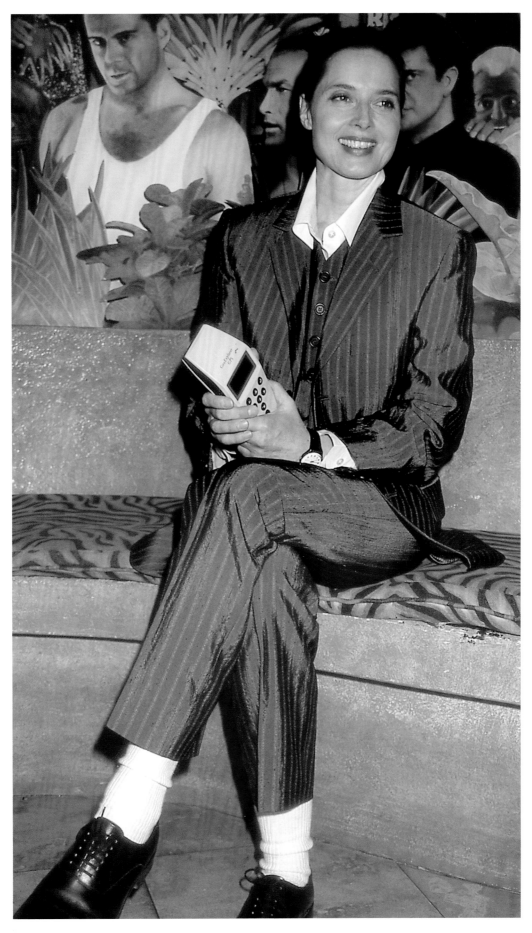

◀ Isabella Rossellini, Planet Hollywood benefit for Diane Fosse,
New York, 1996

Isabella Rossellini, exhibit, Scandinavian House, New York, 2004

Chloe Sevigney, cocktail party, Chelsea
Club, New York, 1999

▶ Elizabeth Hurley, Valentino dinner
party, Four Seasons Restaurant,
New York, 2000

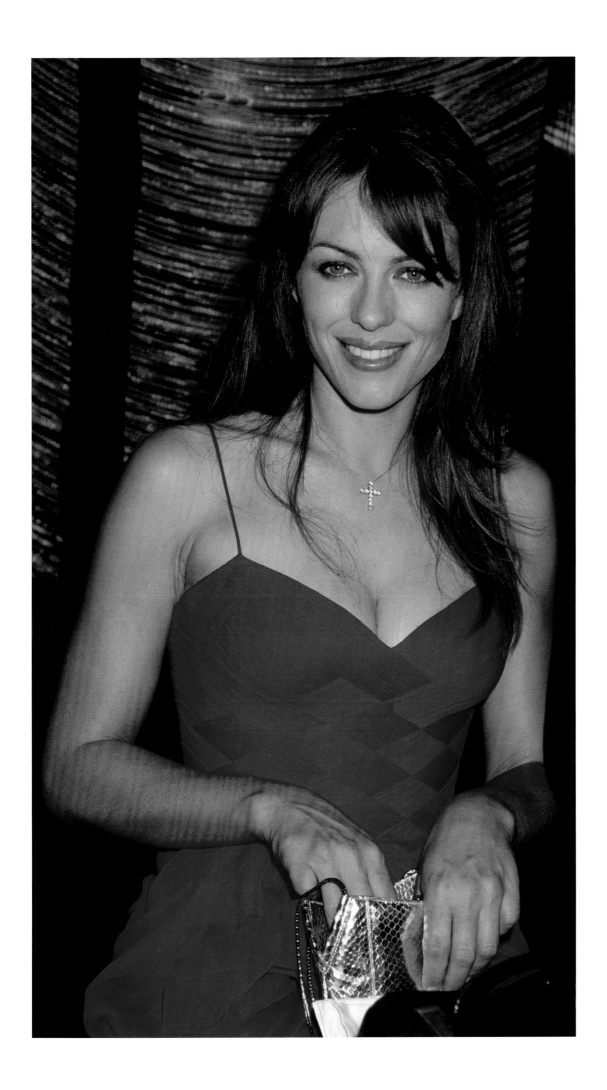

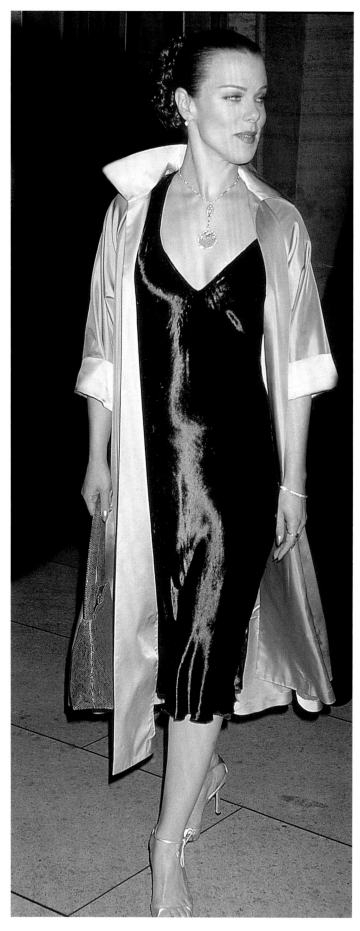

Debi Mazur, film premiere, Lincoln Center, New York, 1999

▶ Elizabeth Hurley, Estee Lauder cosmetics launch, Christie's auction house, New York, 1990

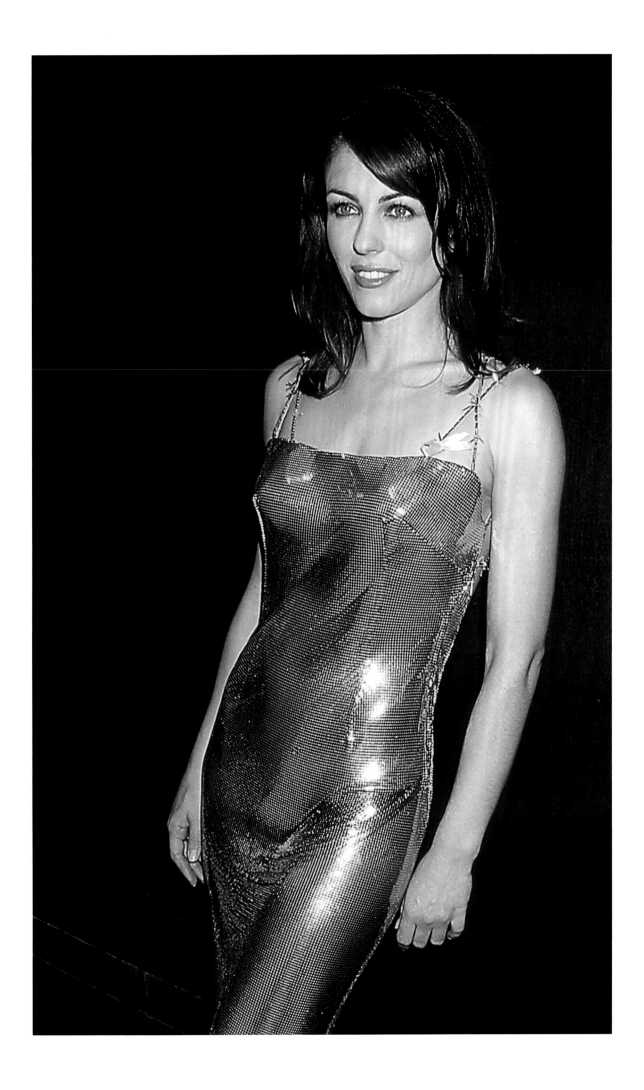

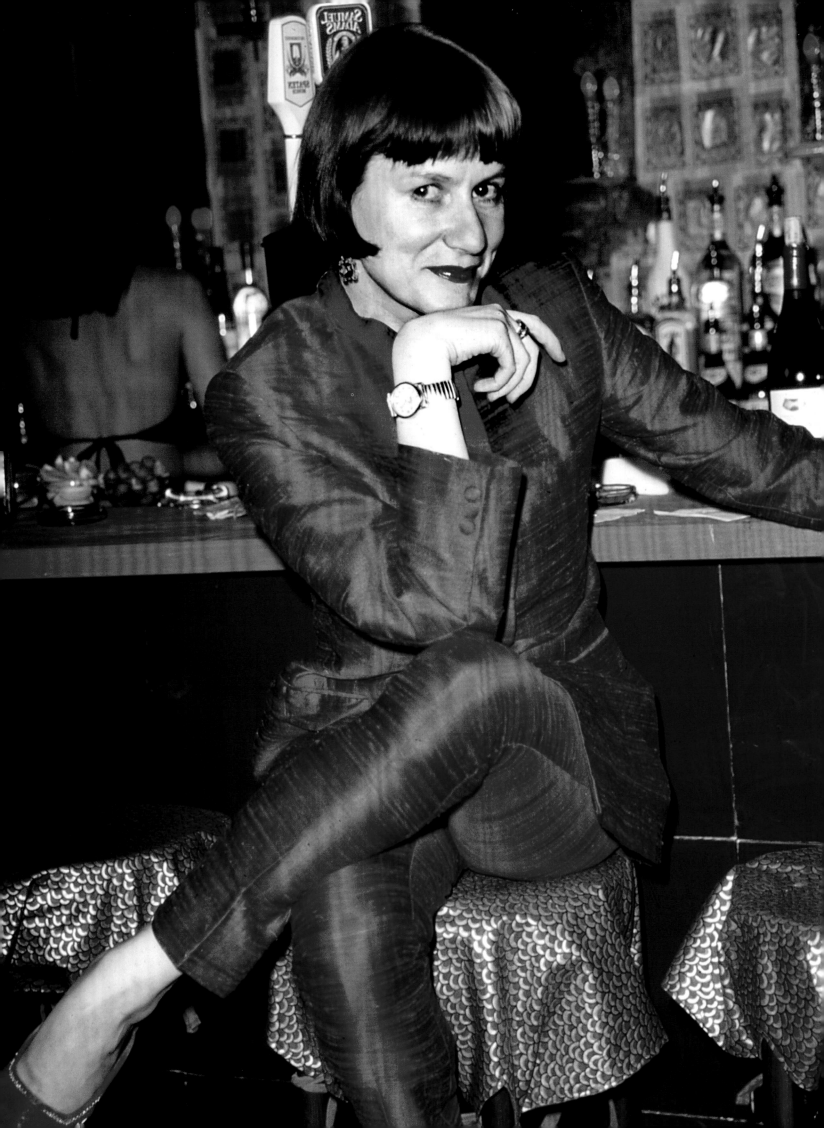

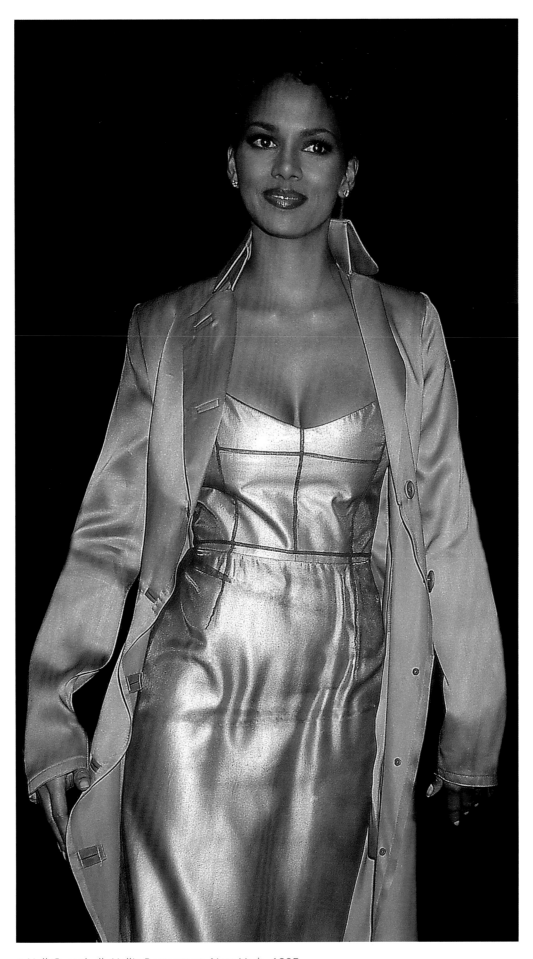

◄ Nell Campbell, Nell's Restaurant, New York, 1995

Halle Berry, film premiere, New York, 1995

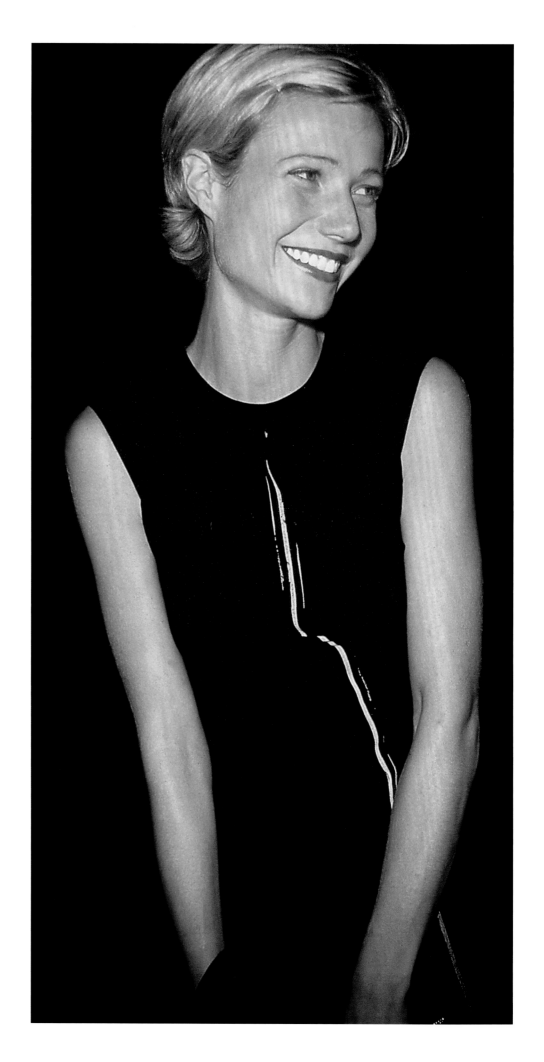

Gwyneth Paltrow, dinner at the Four
Seasons Restaurant. New York, 1995

▸ Kim Cattrall, cocktail party, Cartier
Boutique, New York, 2008

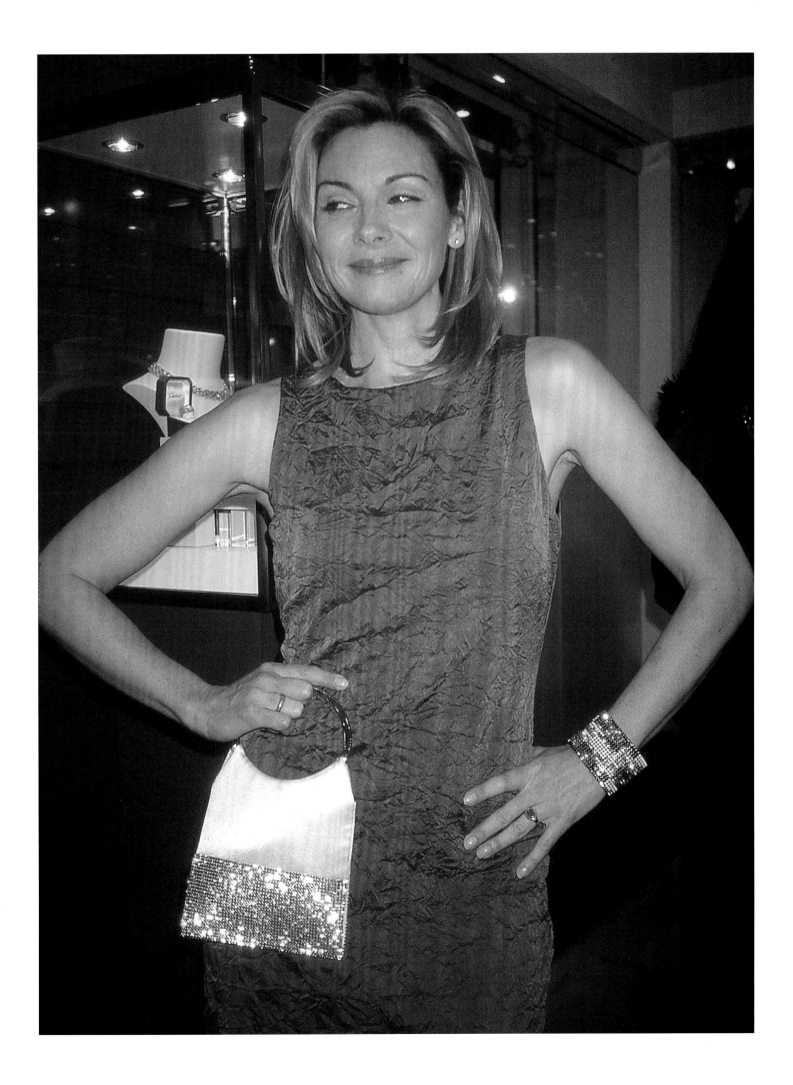

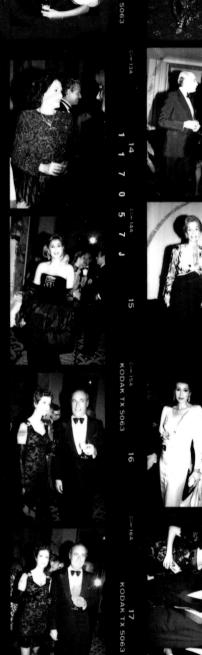
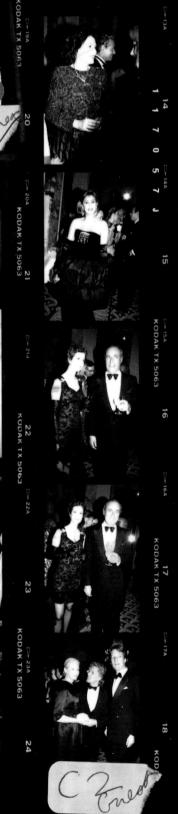
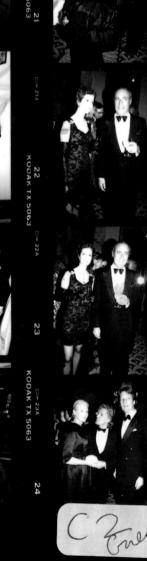

Subjects on Back

Contact #25
© ROSE HARTMAN
Original Print Set

Dutchess of Feira Retorno

No Kempner

Domingo

V Kasparov

C Zucca

Fadde

KODAK TX 5063

JET-SET

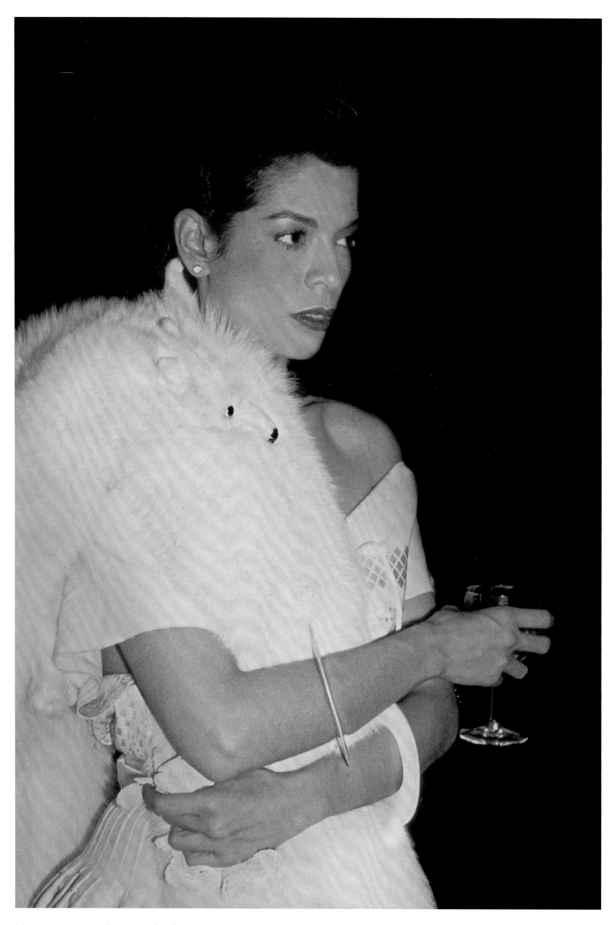

Bianca Jagger, private cocktail party at Halston's townhouse,
New York, 1978

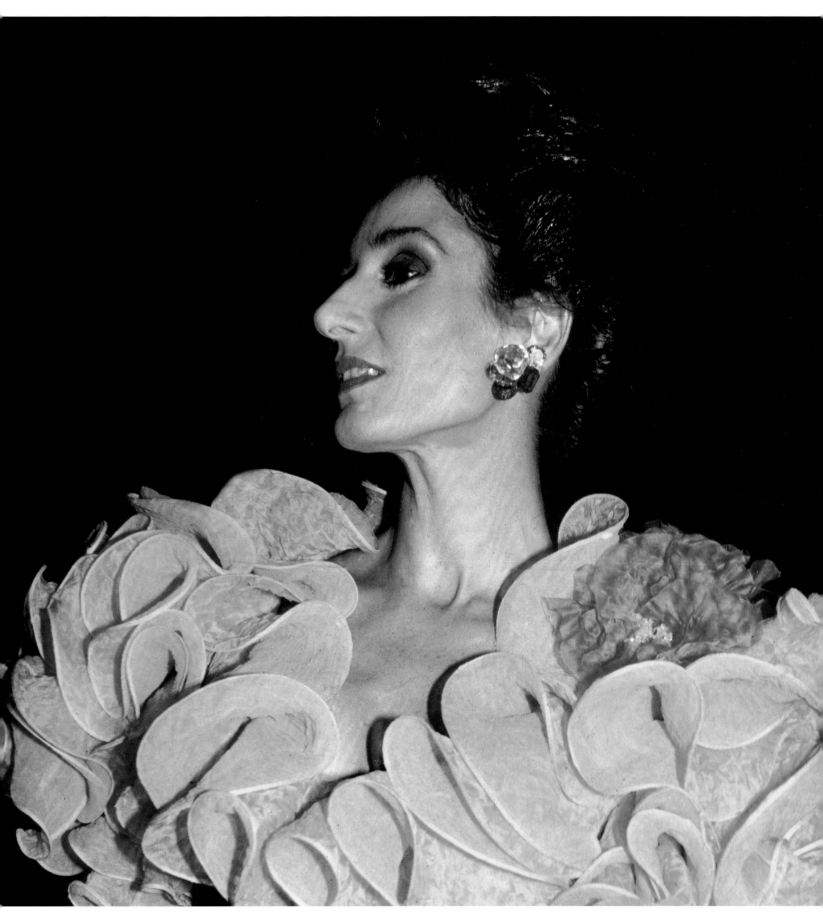

Nati Abascal (Duchess of Sevilla), Spanish Institute gala, Plaza Hotel, New York, circa 1984

Overleaf: Bianca Jagger celebrating her birthday at Studio 54, New York, 1977

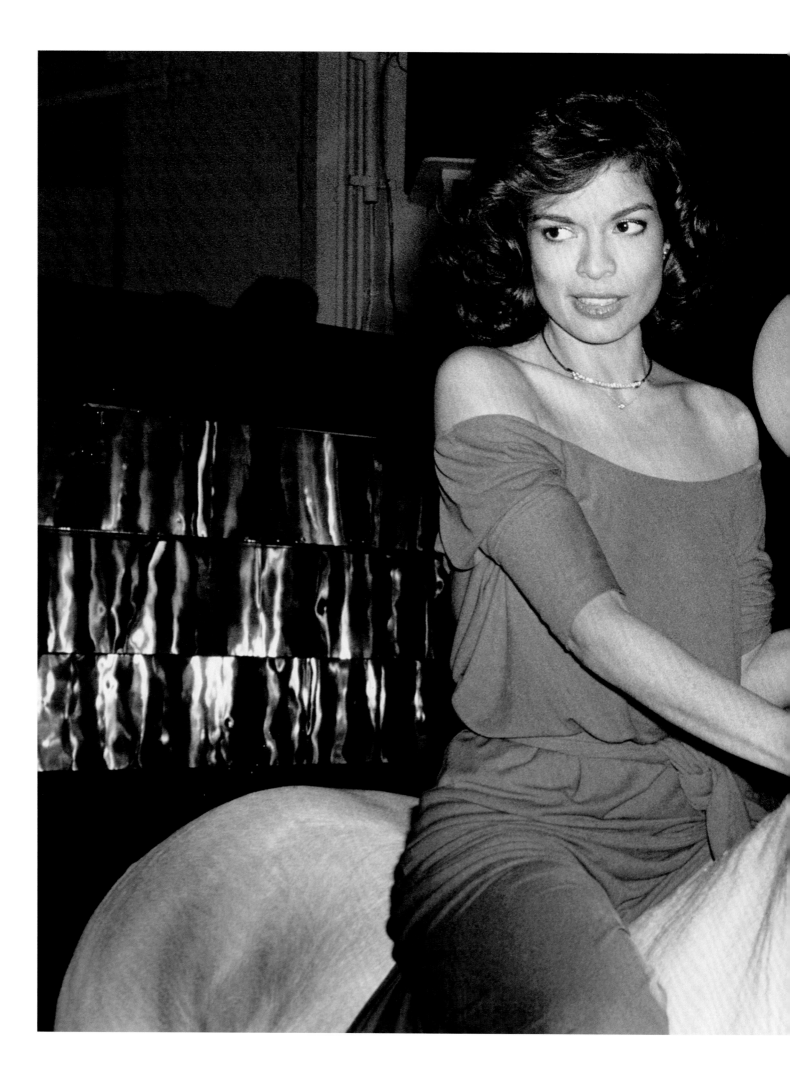

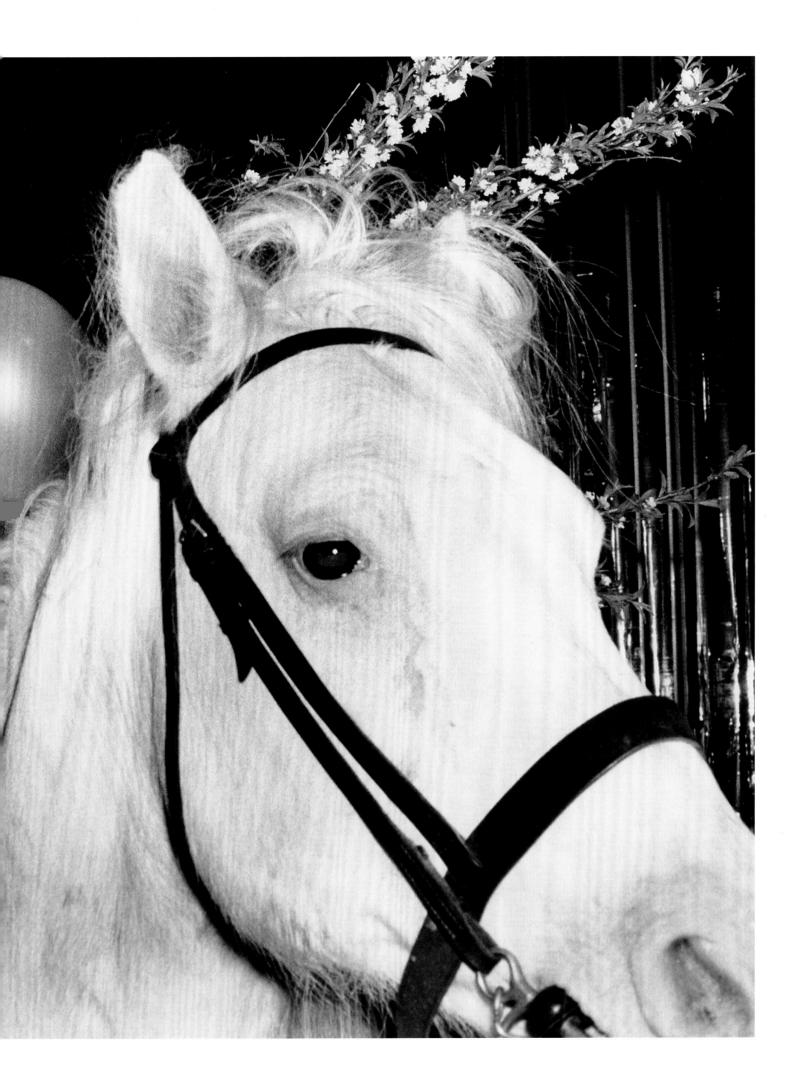

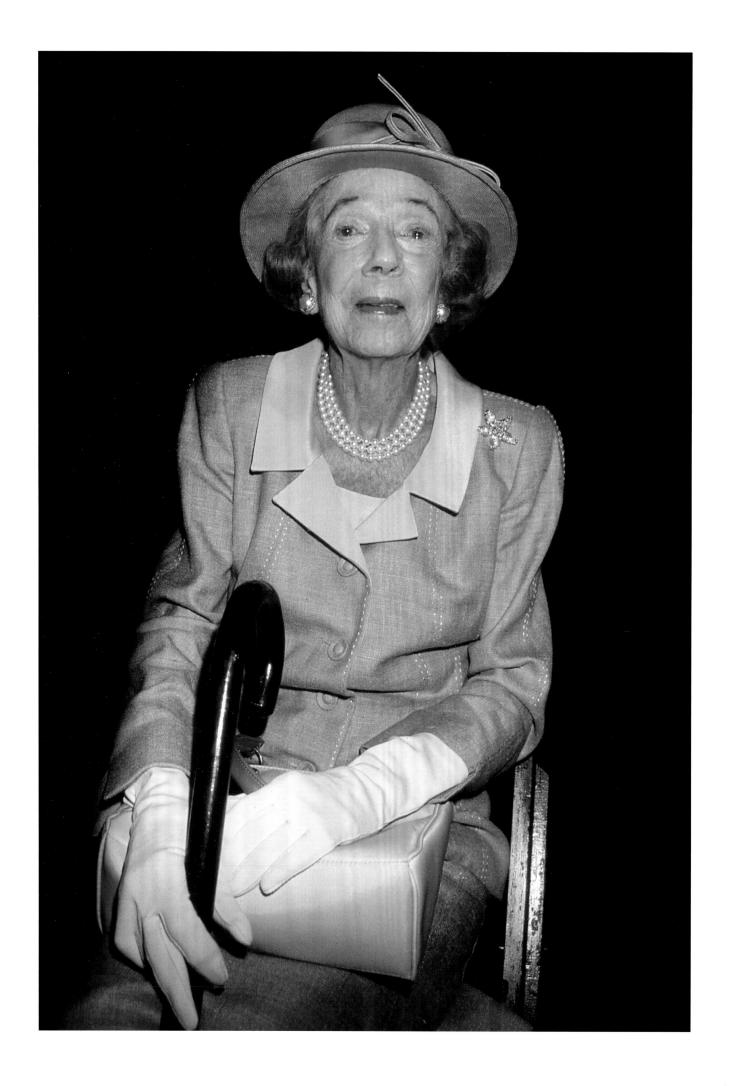

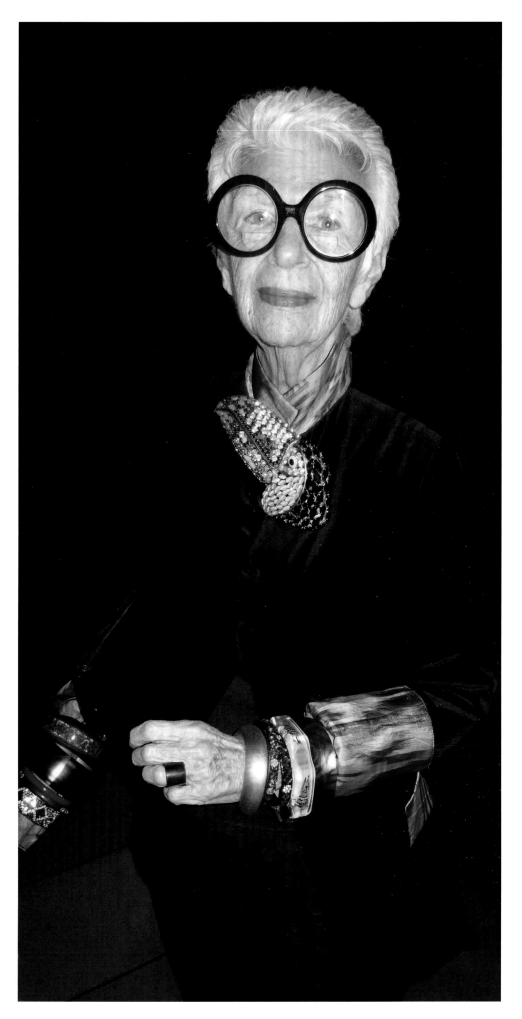

◀ Brooke Astor, Oscar de la Renta
fashion show, Bryant Park tents,
New York, 1995

Iris Apfel, book party, Diane von
Furstenburg's Boutique, Meatpacking
District, New York 2010

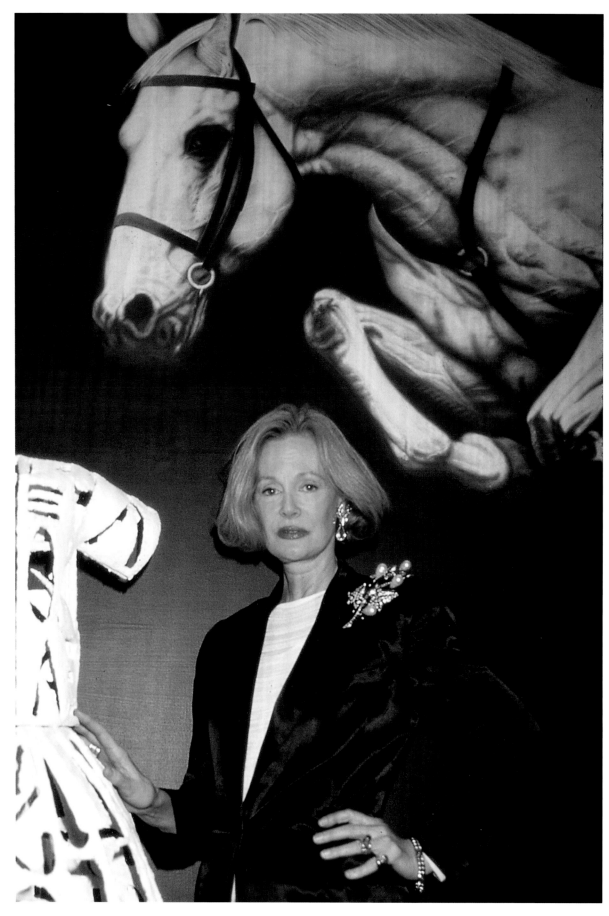

Monique Knowlton, art dealer, dinner party at her Soho loft,
New York mid-1980s

▸ Nan Kempner and Kenneth Jay Lane, preview, Christie's Auction
House, New York, 1989

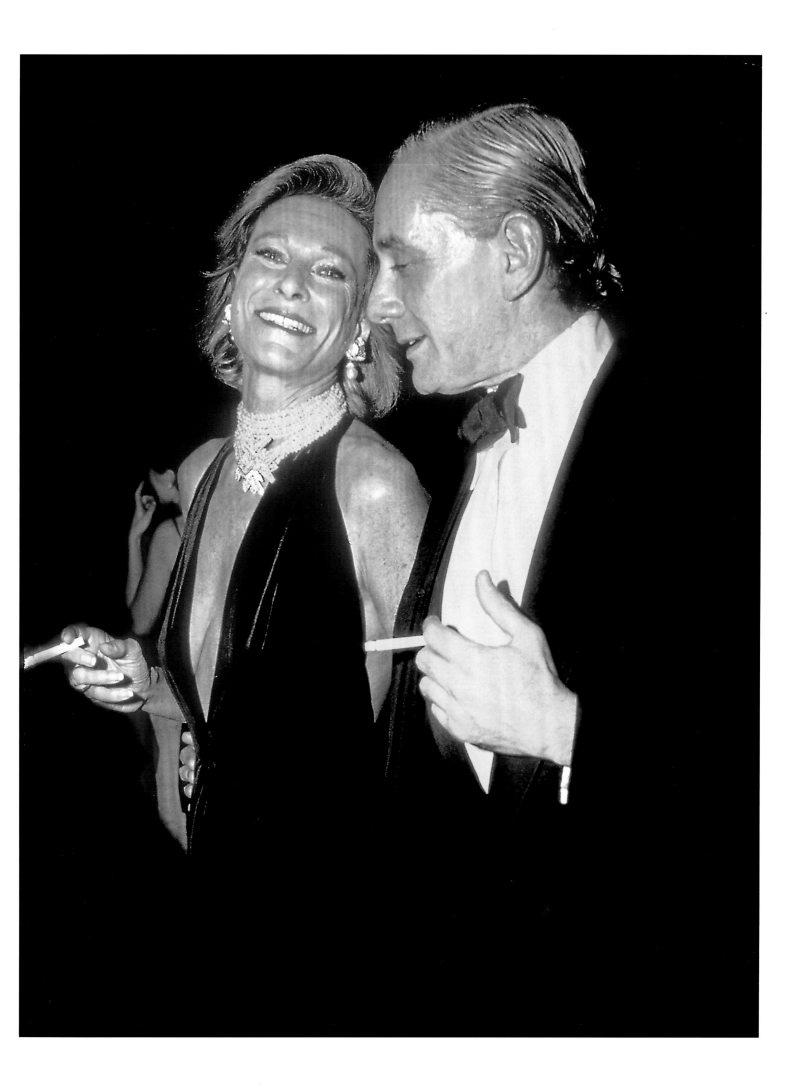

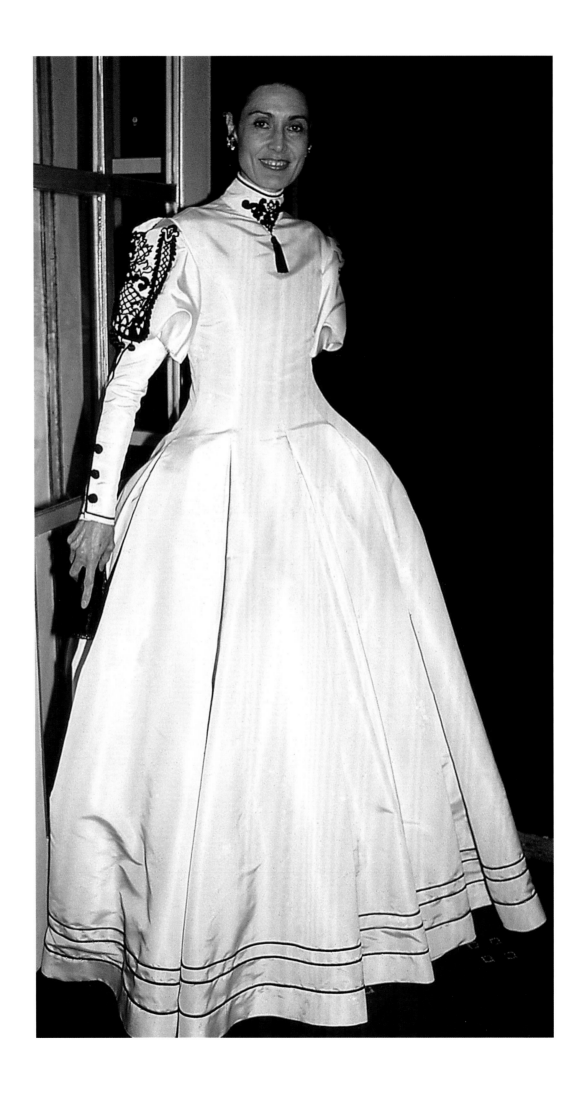

◀ Beatrice Santo Domingo, Spanish
Institute gala, Plaza Hotel,
New York, circa 1984

Anouk Aimee, Armani retrospective
private preview, Guggenheim
Museum, New York, 2000

Nina Griscom, fashion show, Bryant
Park tents, New York, 1995

▸ Nina Griscom, fashion show, Bryant
Park tents, New York, 1999

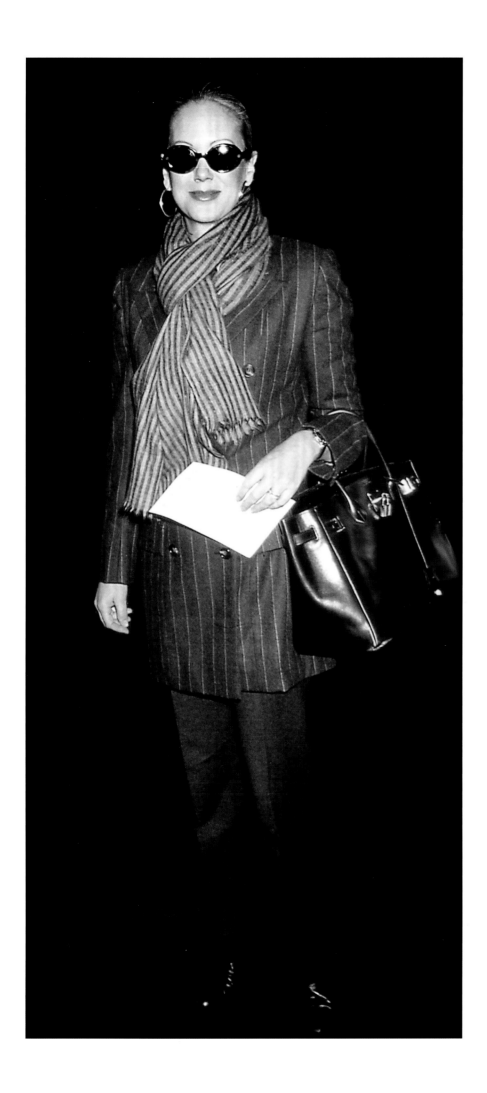

Countess Simonetta Brandolini, Lynn
Wyatt, Nan Kempner, Valentino
celebration, Xenon, New York, 1980

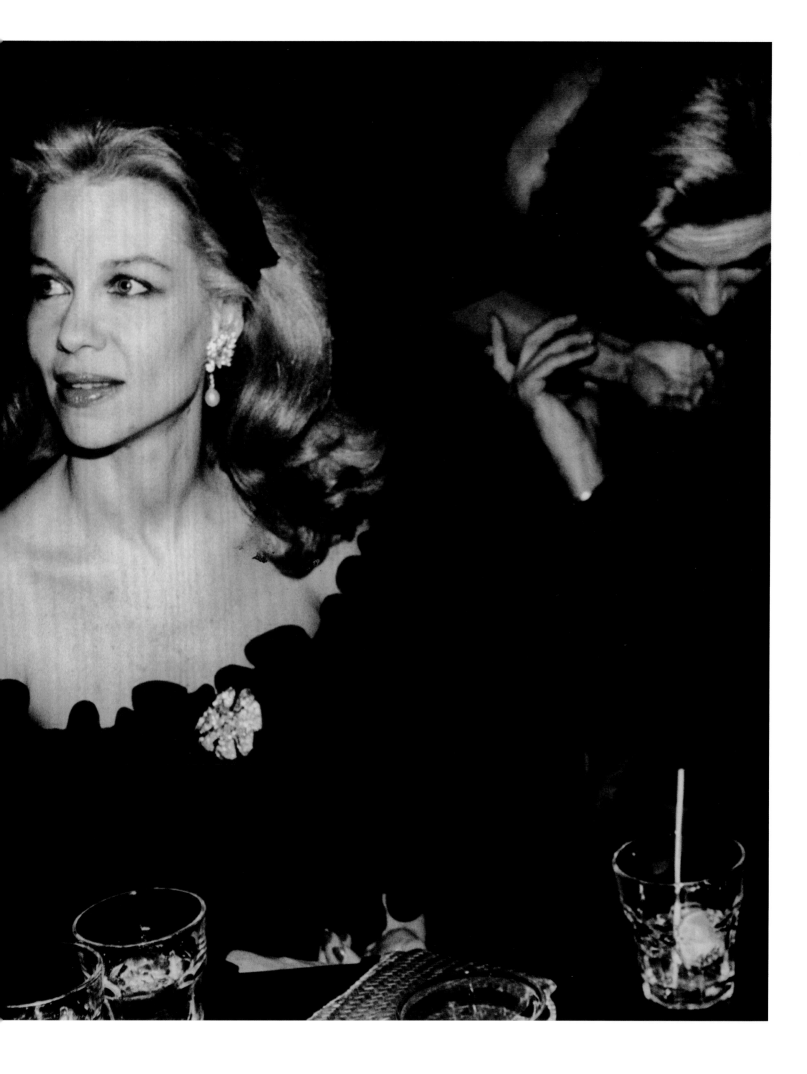

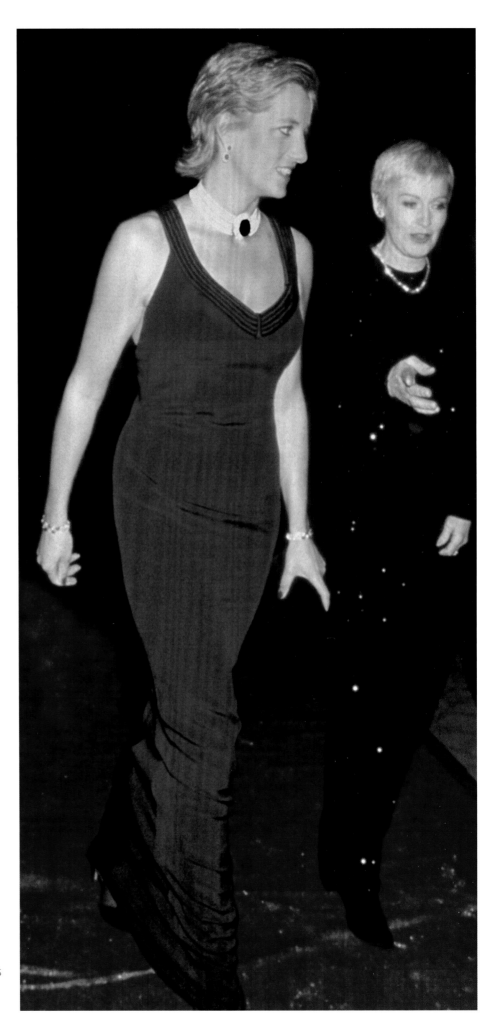

Diana Princess of Wales and Liz Tilbiris
at Council of Fashion Designers' Gala
at Lincoln Center, New York, 1995

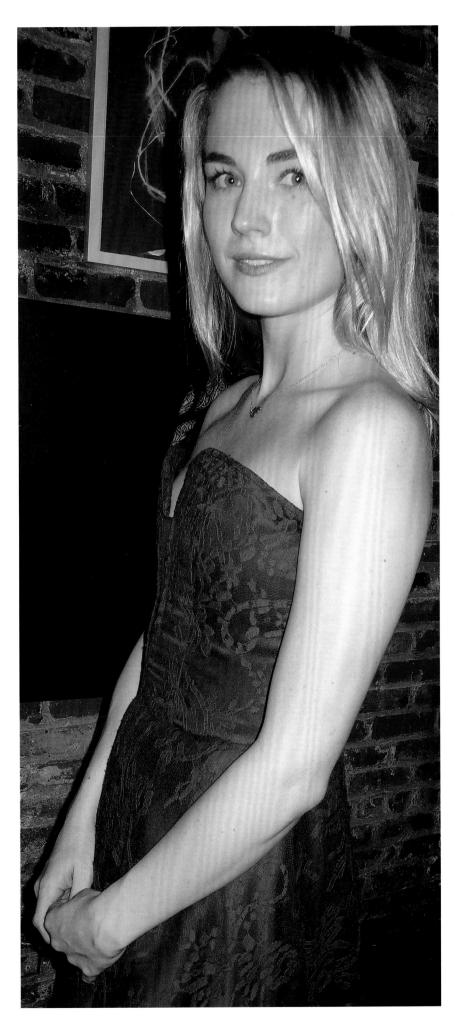

Amanda Hearst, West Village art
gallery, New York, 2008

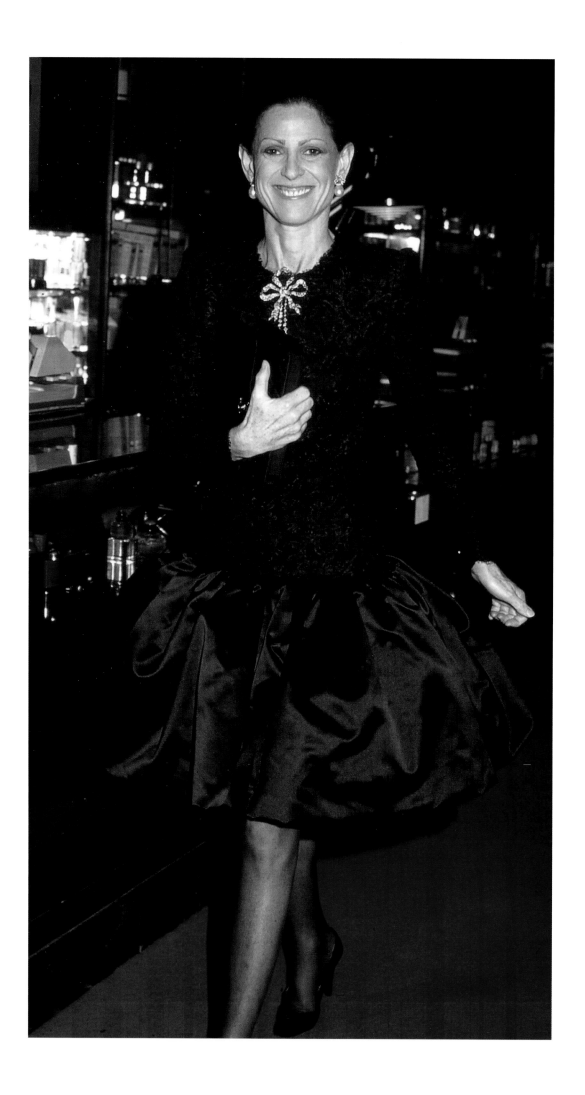

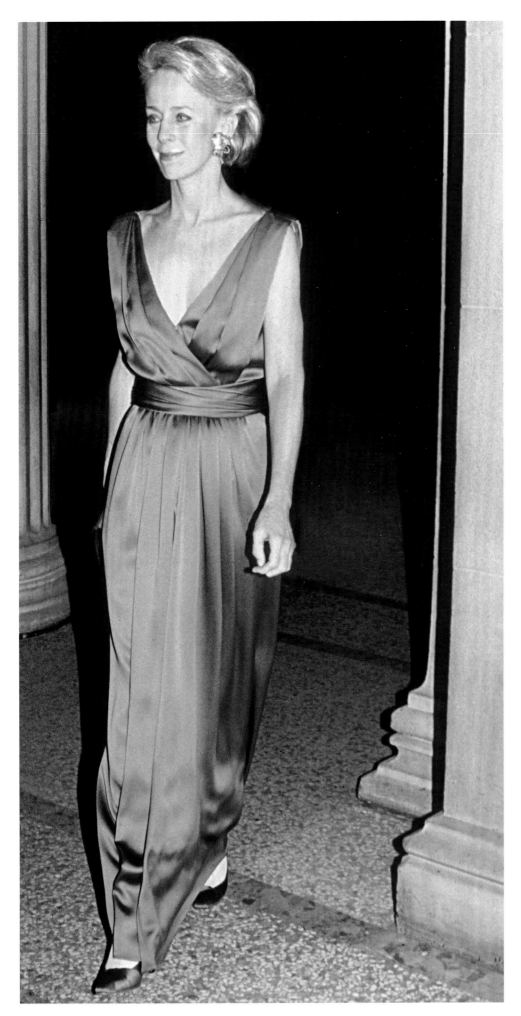

◀ Annette de la Renta, party for Oscar de la Renta, Saks Fifth Avenue, New York, 1982

Anne Bass, Costume Institute Gala, Metropolitan Museum of Art, New York, 1994

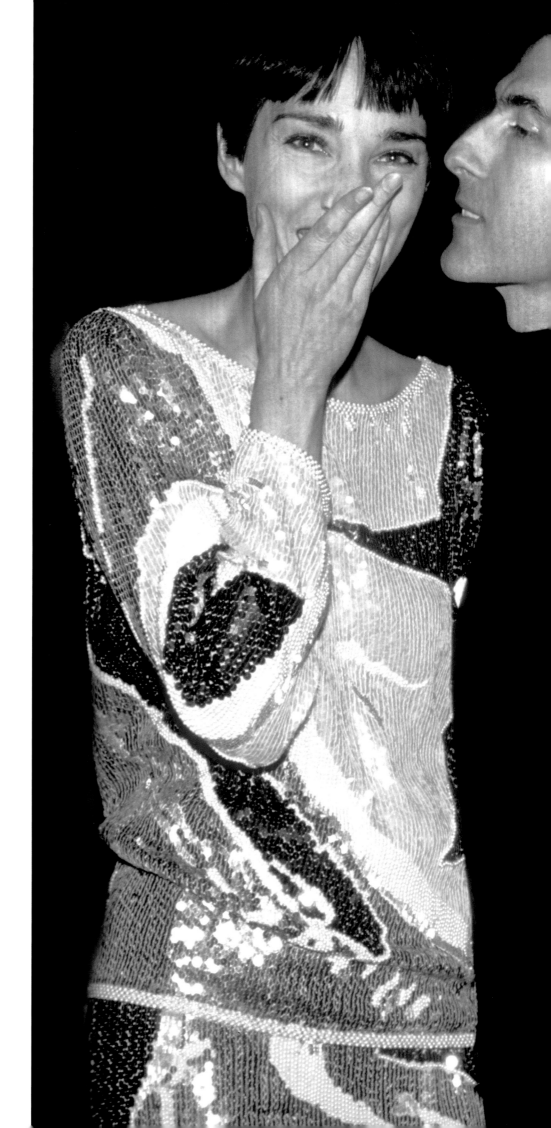

Dovanna, David Croland, DD Ryan,
cocktail party, private home,
New York, 1985

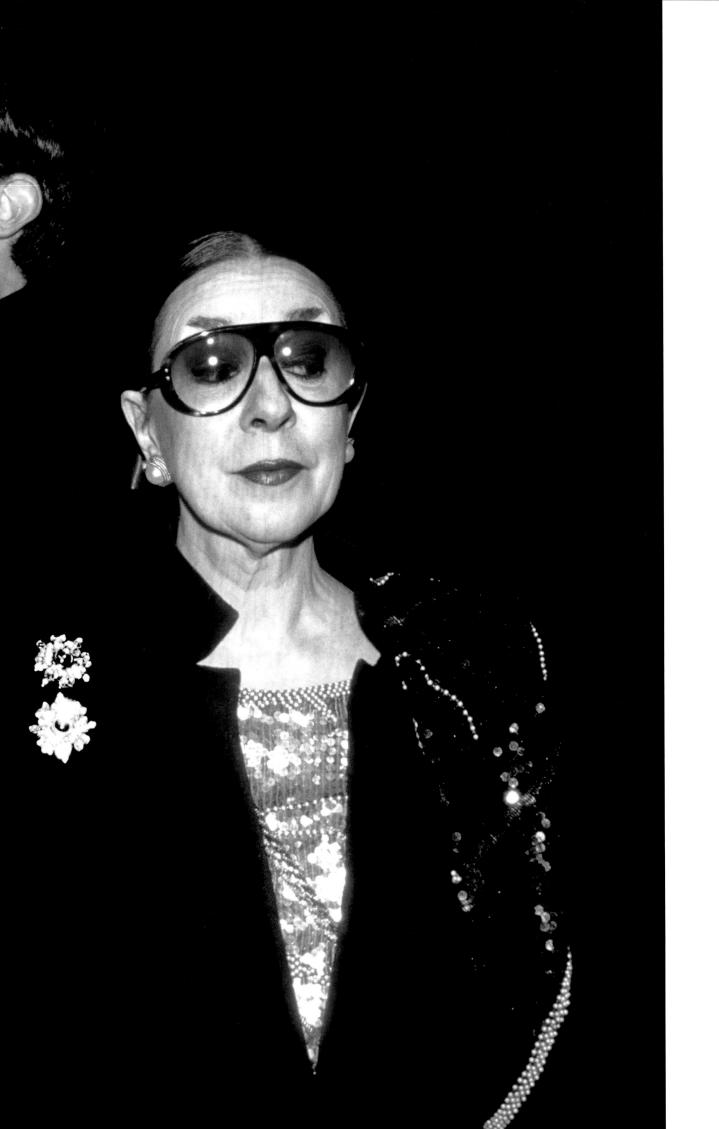

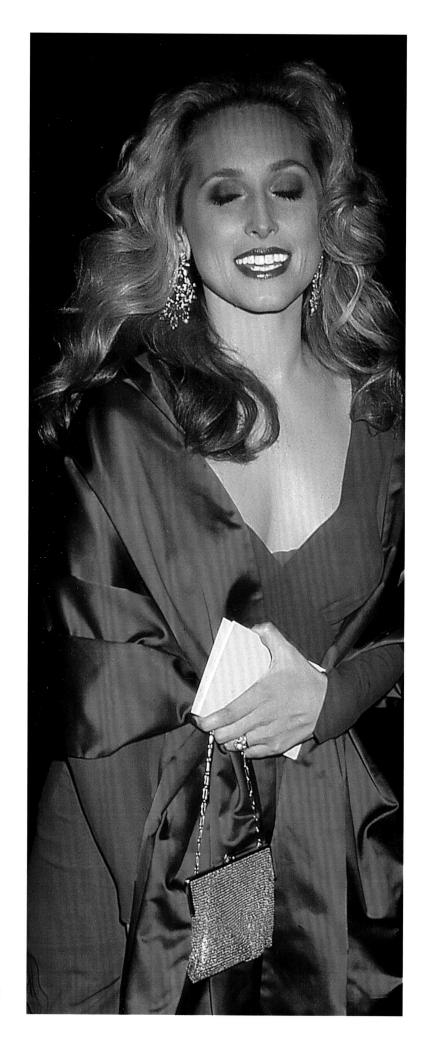

Pia Getty, Gala, Cipriani, New York, 1998

▸ Carolyn Roehm, Gala dinner party in Chelsea, New York, 1988

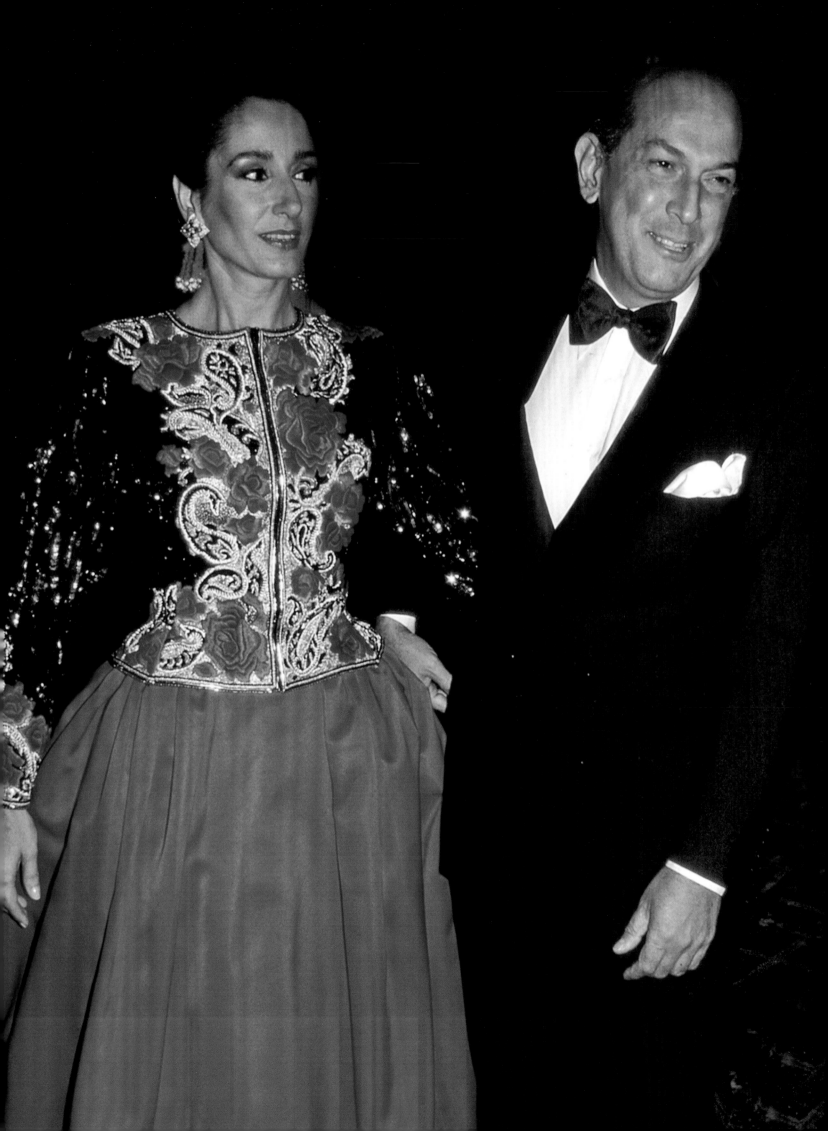

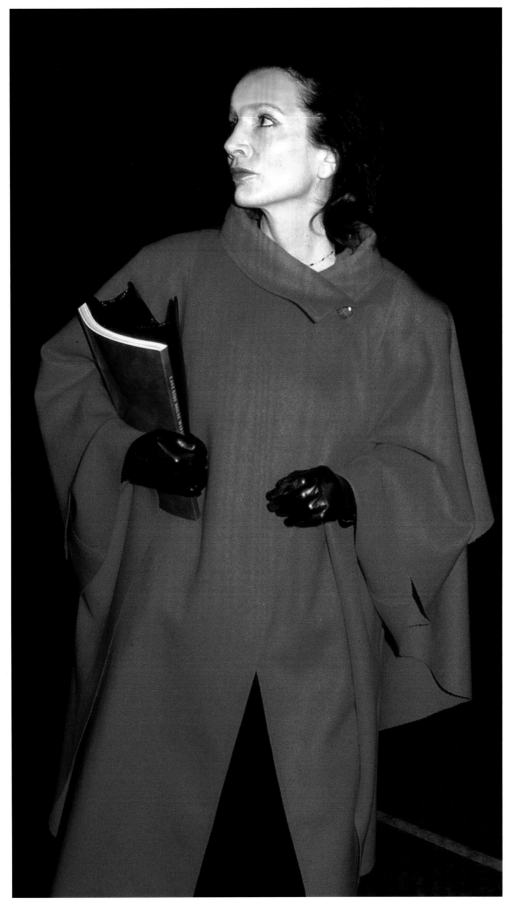

◀ Nati Abascal (Duschess of Feria) and Oscar de la Renta, Spanish
Institute Gala, Plaza Hotel, New York, 1985

Lee Radziwill, New York Antiques Show Gala, Park Avenue
Armory, New York, 1998

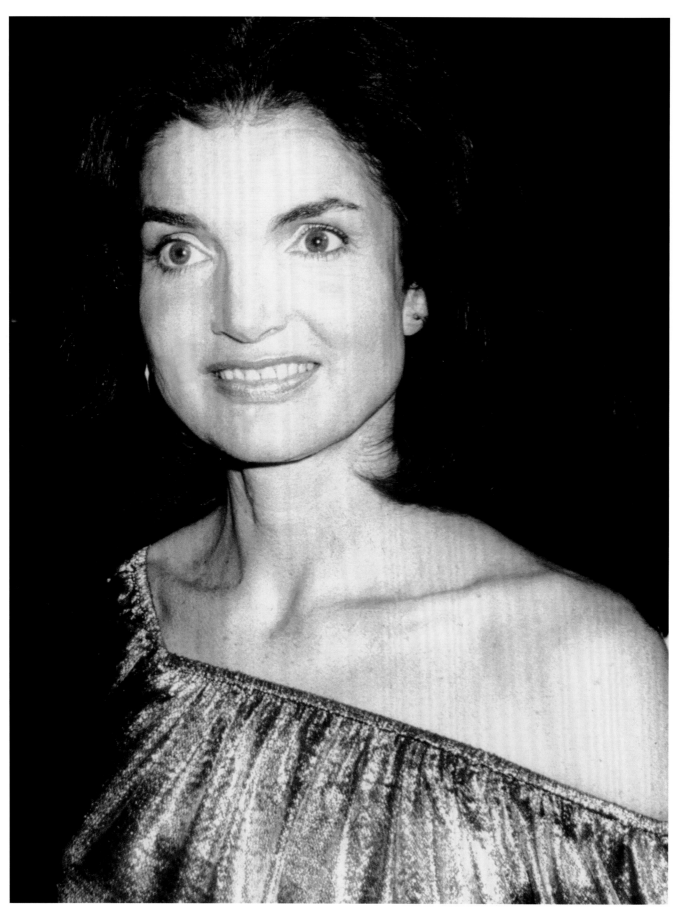

Jackie Onassis, Louis Falco Dance Company benefit, Soho,
New York, 1981

▶ Joan Hemingway in Dior wedding gown, Sun Valley, Idaho,
1976

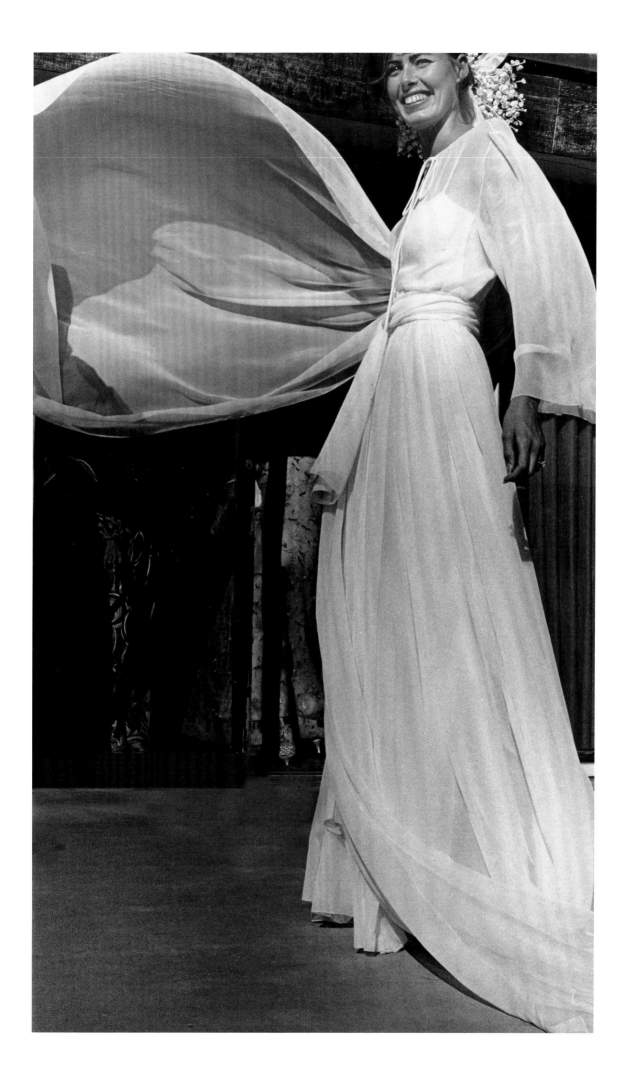

FASHIONISTAS

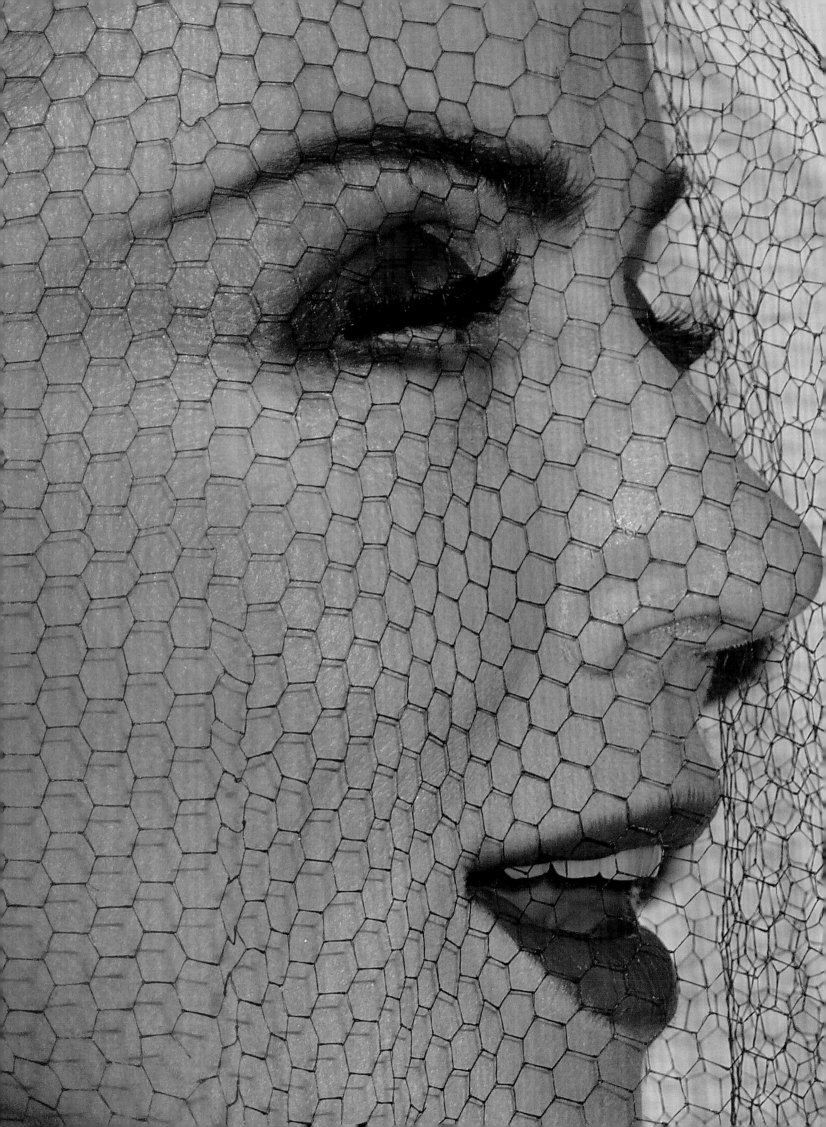

◄ Daphne Guinness in Philip Tracey veil, David LaChapelle's dinner at Le Brasserie, New York, 2011

Daphne Guinness, VIP opening of her couture collection, Fashion Institute of Technology, New York, 2011

Daphne Guinness, birthday party for
Anthony Haden-Guest, 293 Club,
New York, 2008

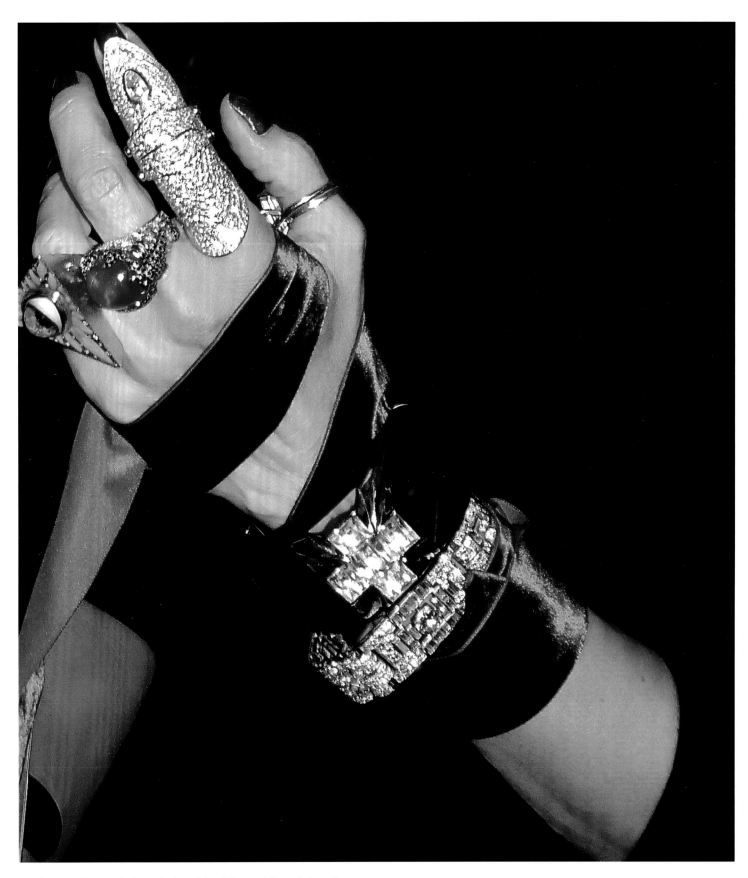

Daphne Guinness bejeweled and beribboned (hand detail),
Fashion Institute of Technology, New York, 2011

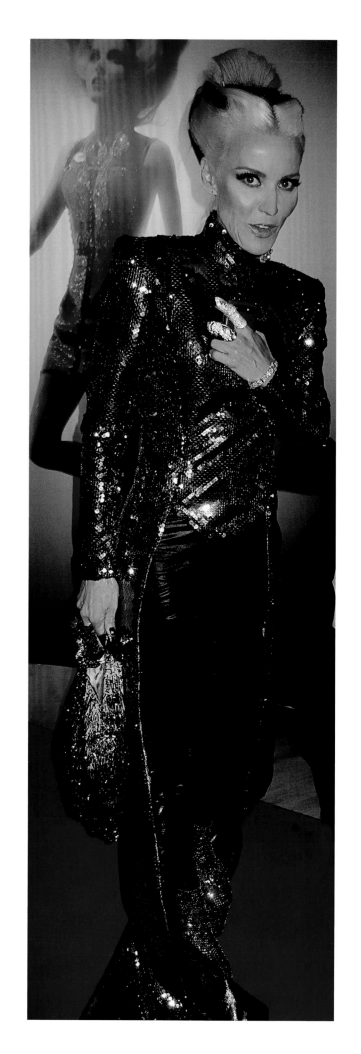

Daphne Guinness in front of David LaChapelle portrait, VIP opening for her couture collection, Fashion Institute of Technology, New York, 2011

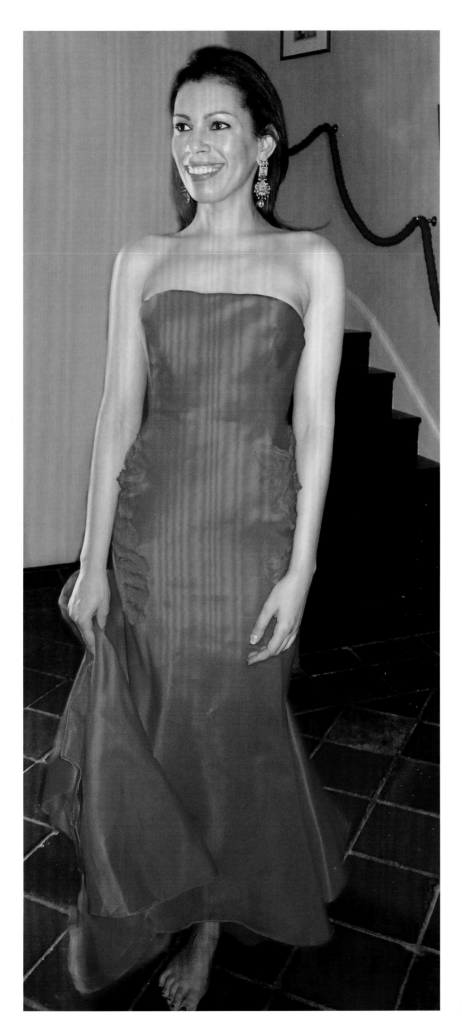

Lady Kingsley (Daniela Lavender),
Spelsbury, Oxfordshire, 2011

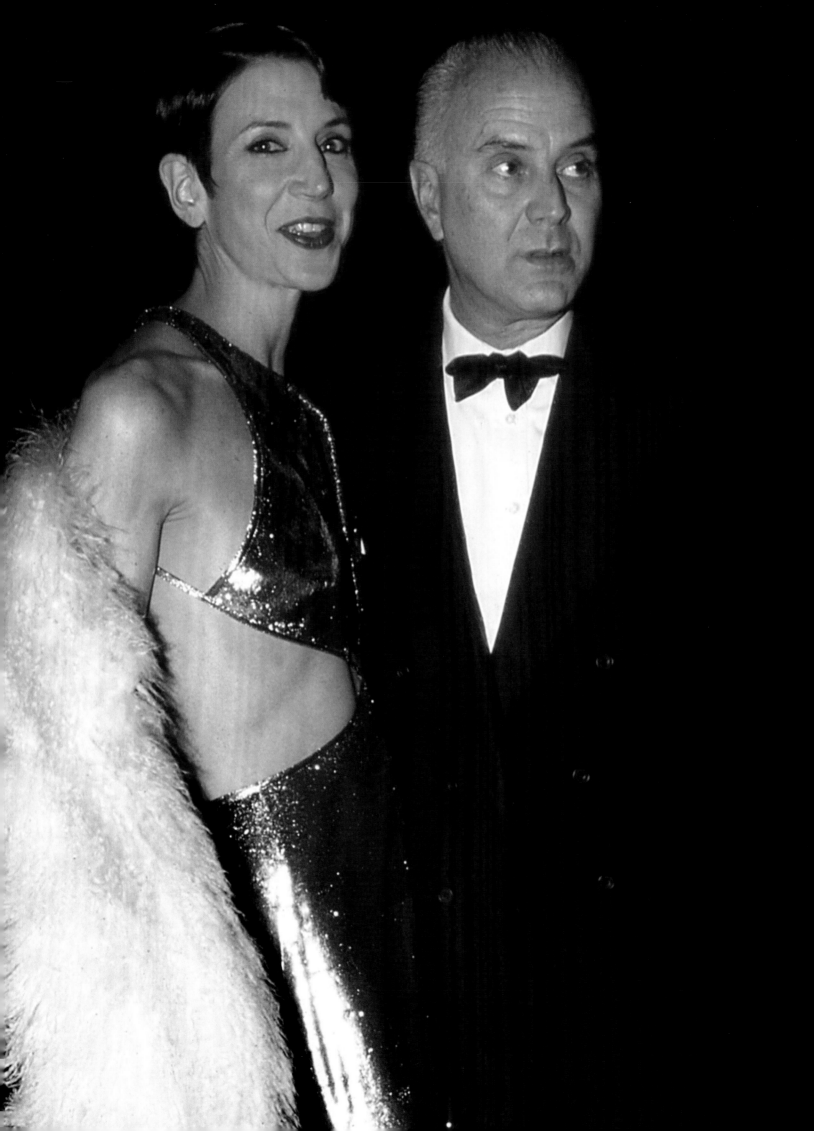

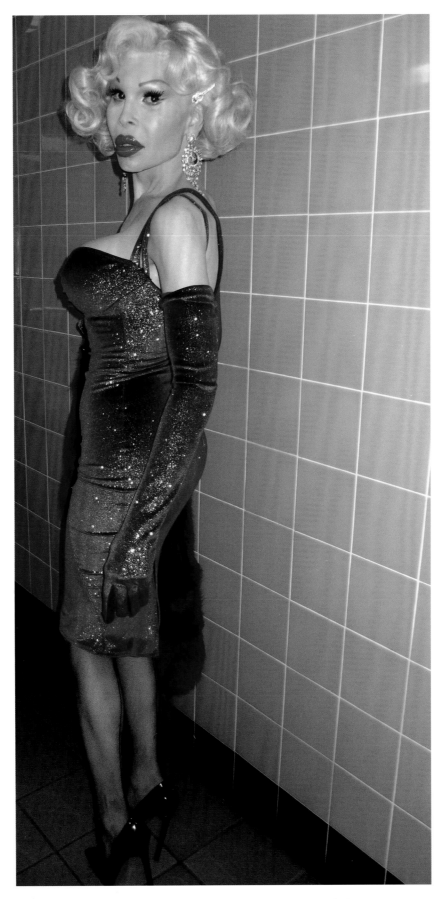

◄ Amy Fine Collins and Manolo Blahnik at art preview, Sotheby's, New York, circa 1990s

Amanda Lepore, ladies' room, opening night, Joey Arias performance, Abron Arts Center, Lower East Side, New York, 2011

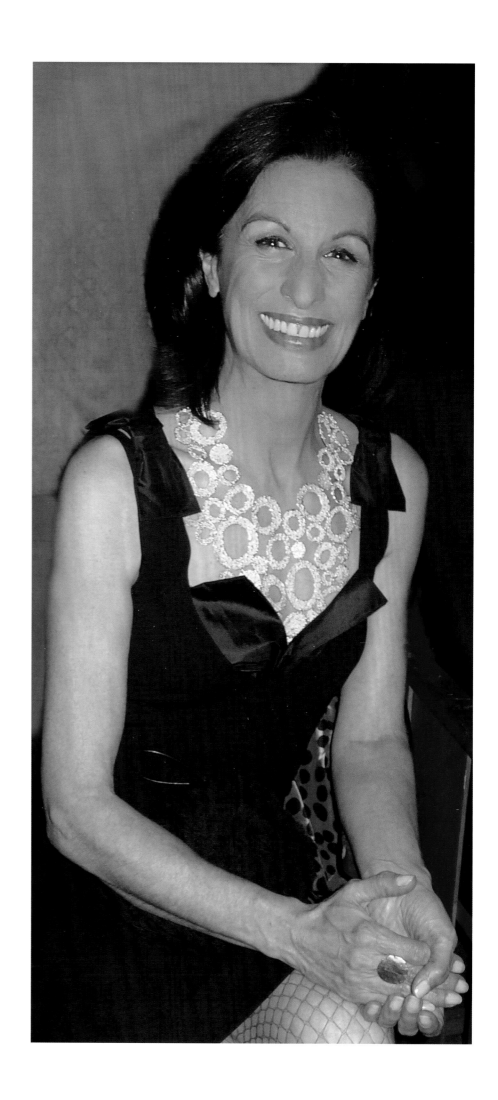

Alba Clemente, private dinner at
Francesco Clemente's loft, Soho,
New York, 2009

Linda Fargo, fashion launch, Bergdorf
Goodman, New York, early 2000s

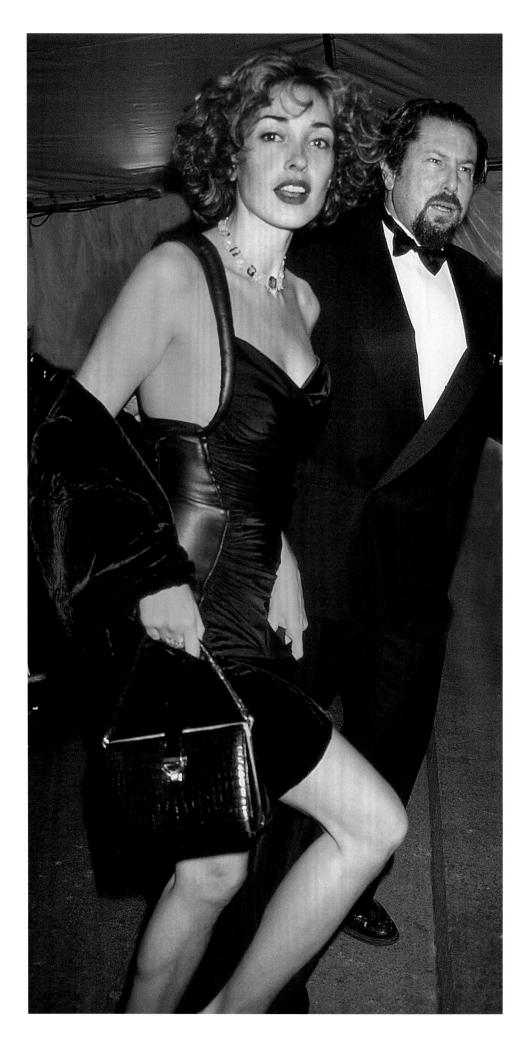

Olatz and Julian Schnabel, Costume
Institute Gala, Metropolitan Museum
of Art, New York, 1997

▶ Loulou de la Falaise, 'Night of Stars',
Pierre Hotel, New York, 1996

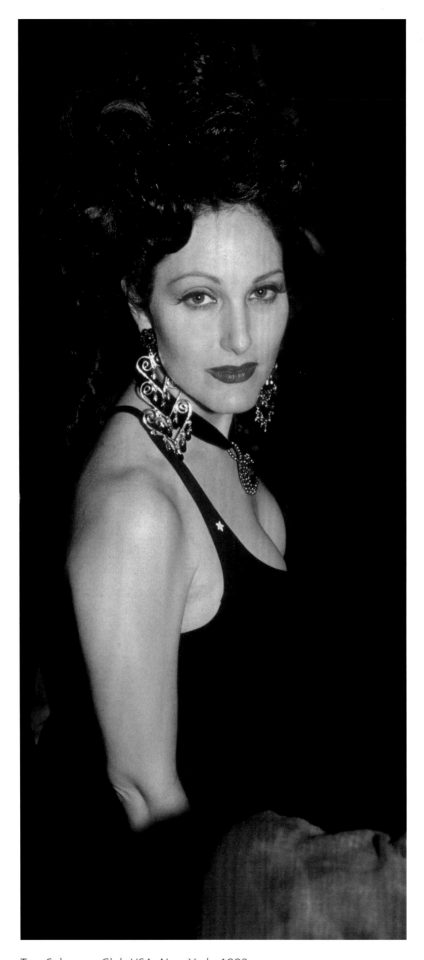

Tara Solomon, Club USA, New York, 1992

▸ Susanne Bartsch, Le Clic, New York, 1986

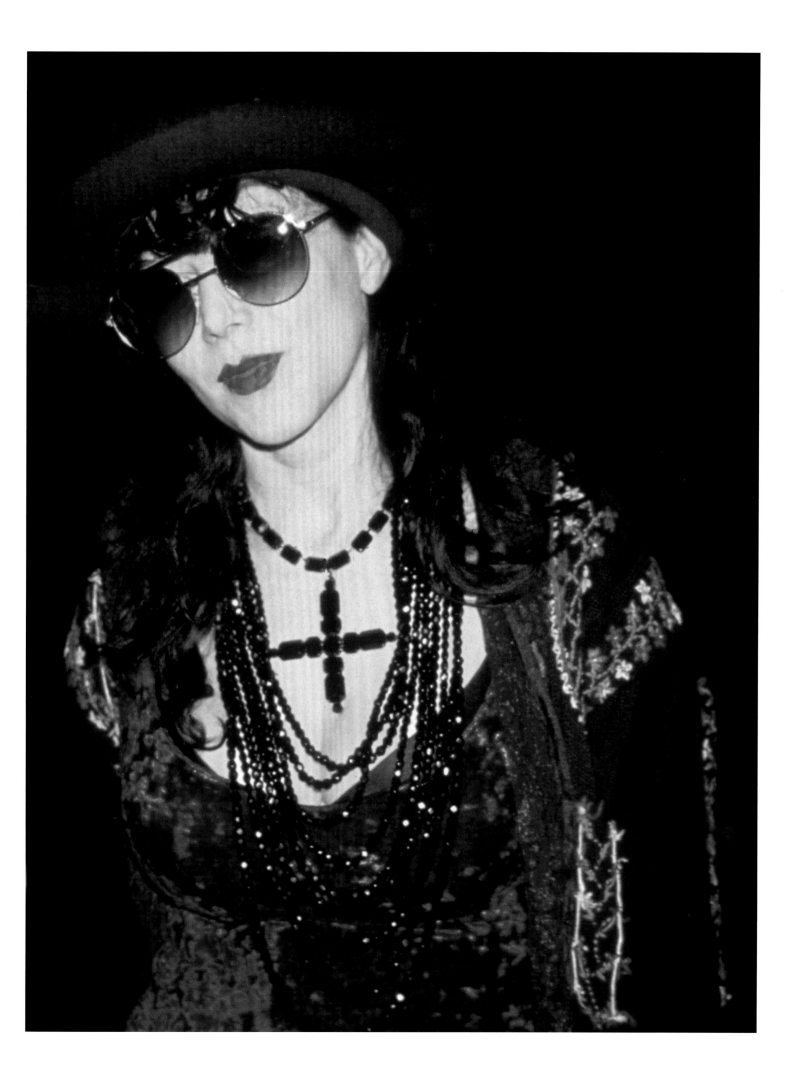

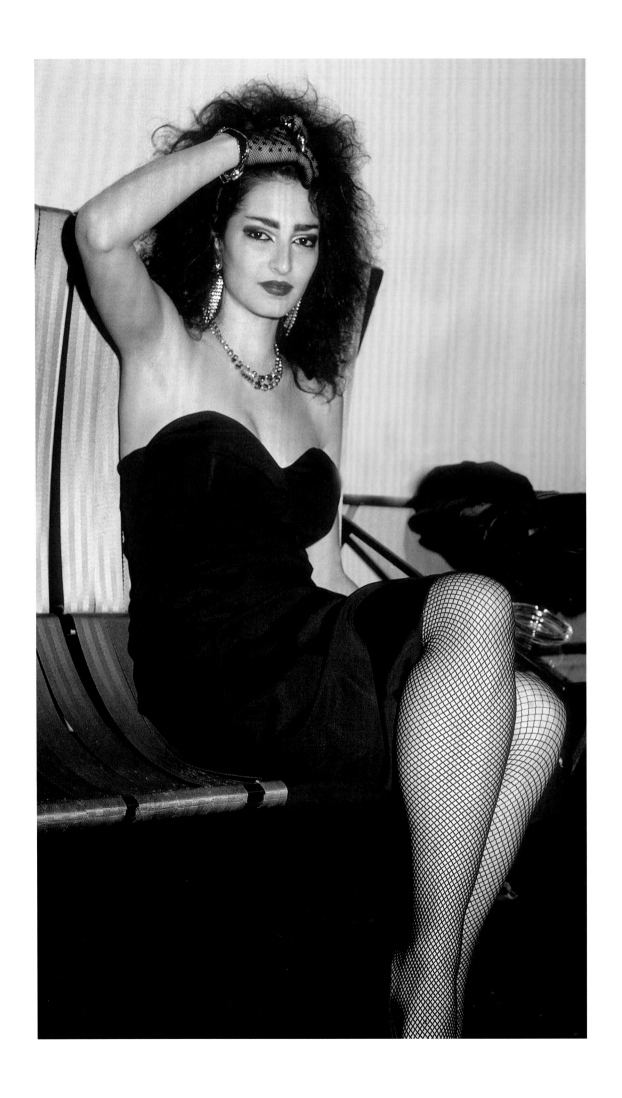

◄ Beauty in black dress, Club MK,
New York, 1986

Tama Janowitz, gallery opening, Soho,
New York, 1990

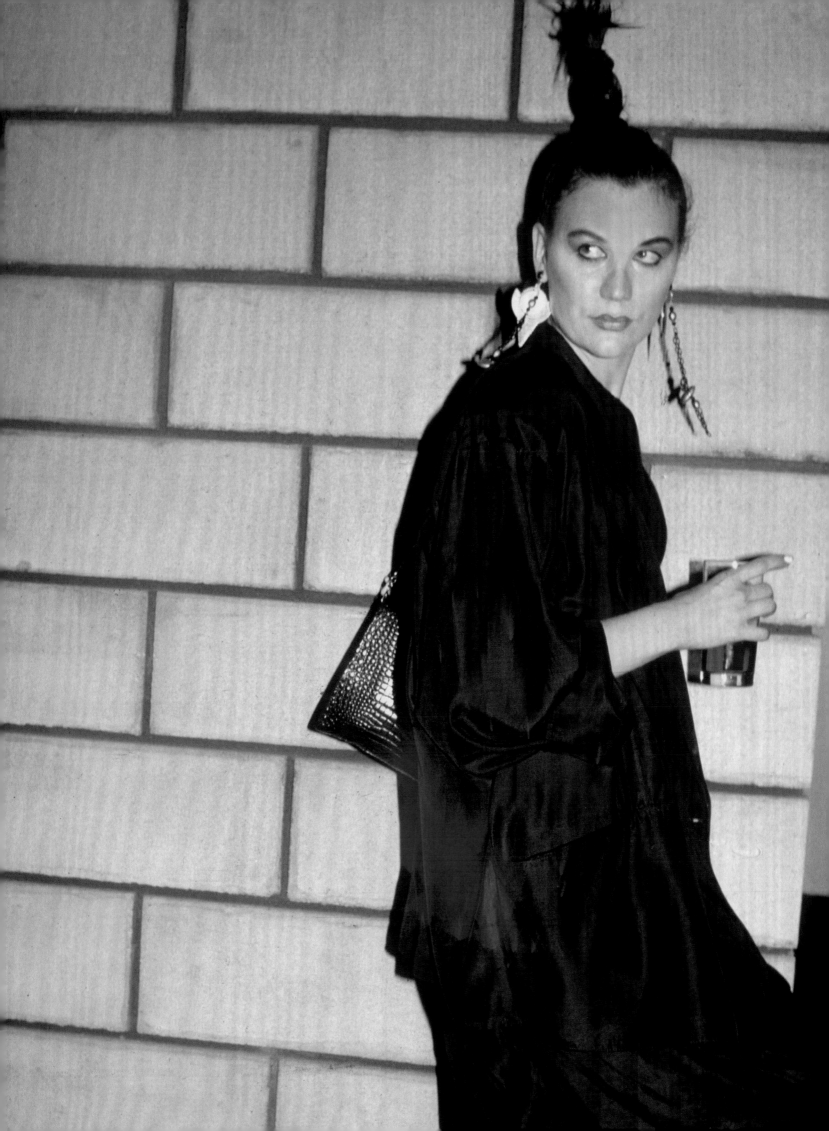

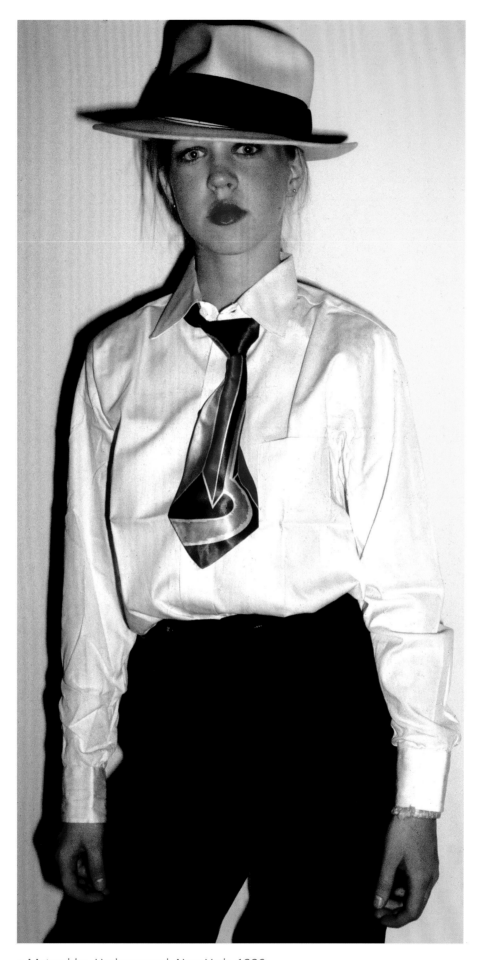

◀ Matuschka, Underground, New York, 1986

Girl in white shirt and hat, Area, New York, 1978

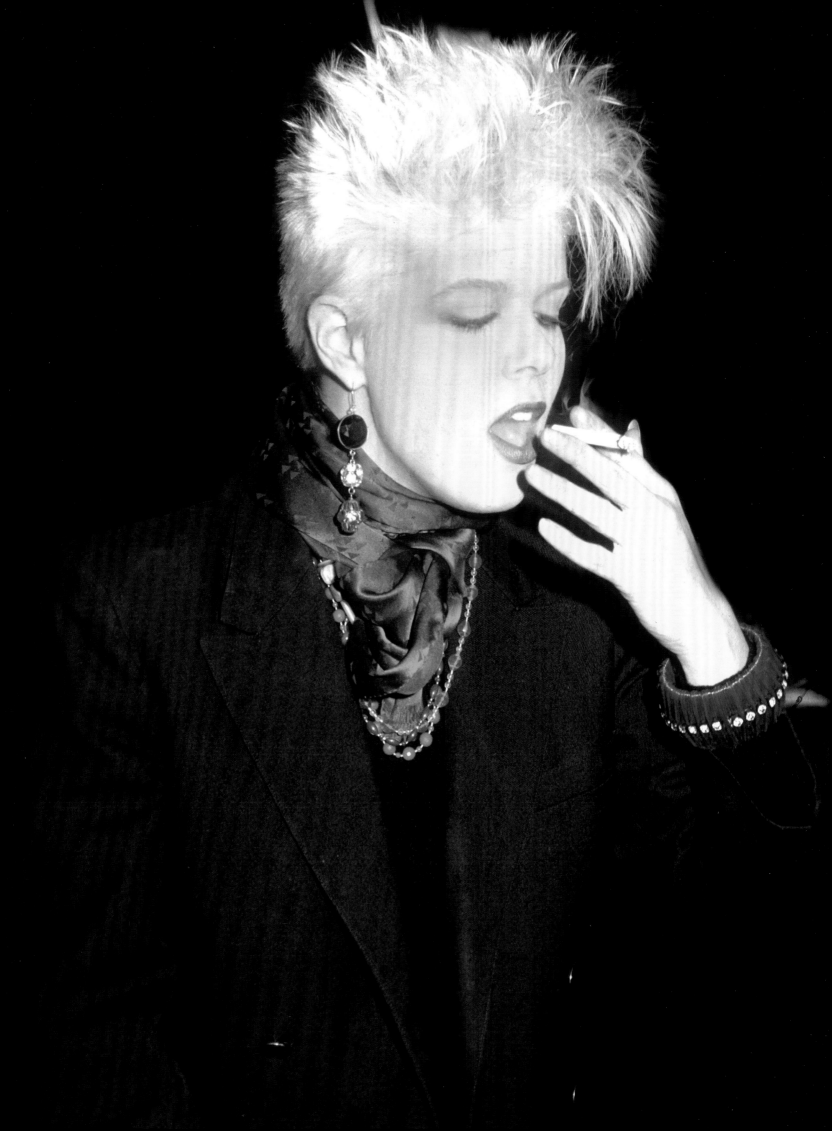

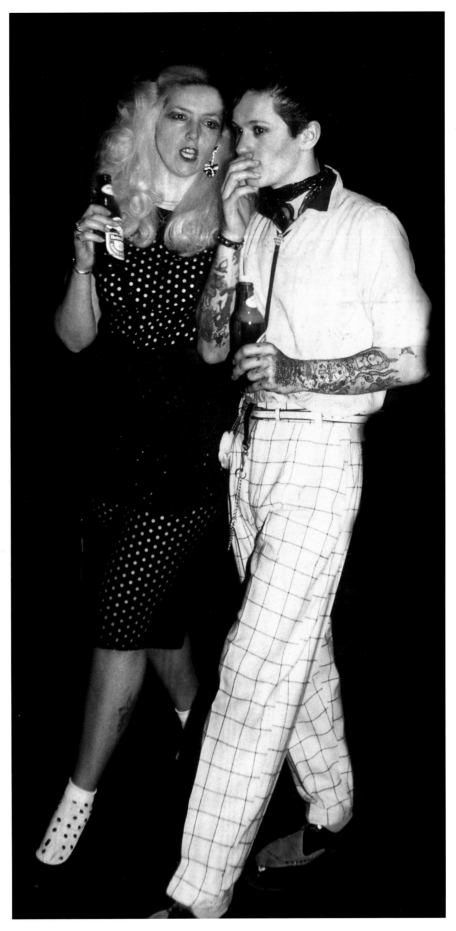

◂ Blond girl smoking, Grand Street bar in Soho, New York, 1984

Black-and-white dressed couple walking through Soho,
New York, 1981

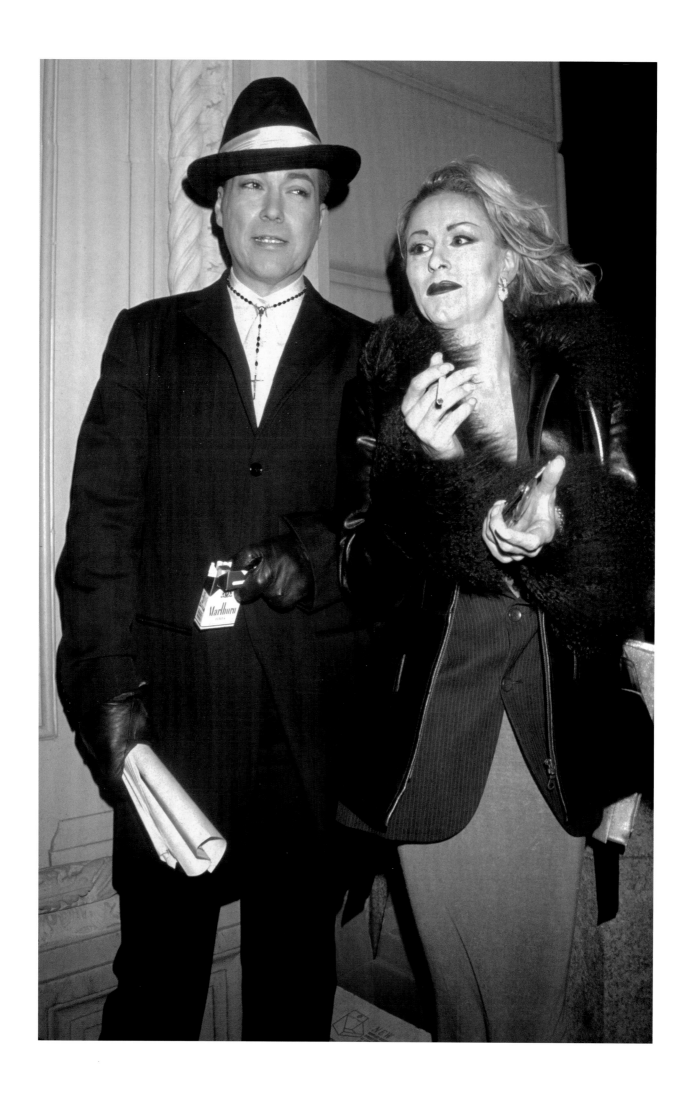

◀ Door people, Club MK, New York, 1984

Girl with upswept hair, Club MK, New York, 1986

Stacey Engman, VIP opening,
Bass Museum, Miami Beach, 2011

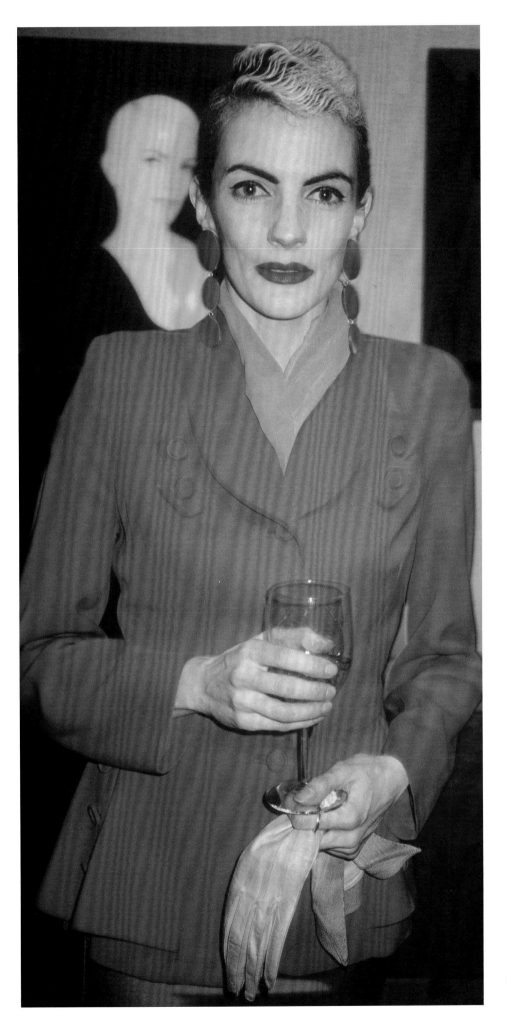

Blond in a red suit, Club MK,
New York, 1986

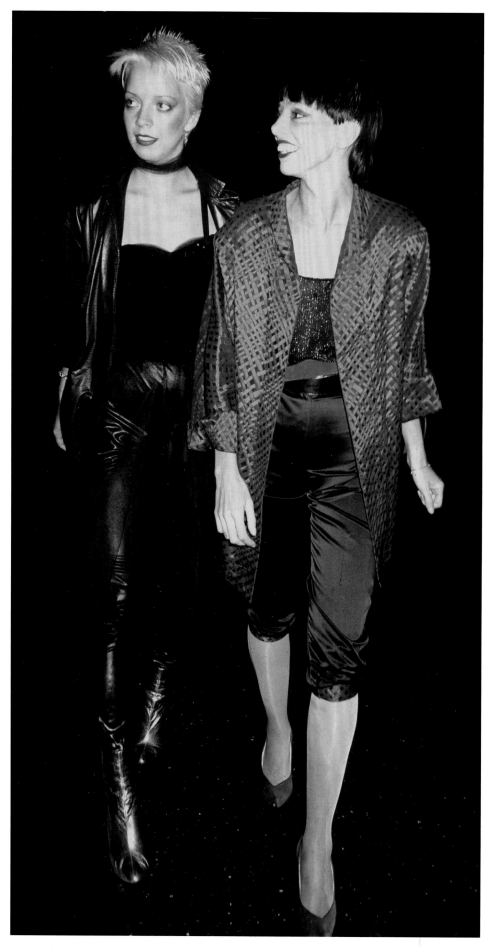

Two girls on their way to a Soho restaurant, New York, 1981

▸ Tattooed couple, Area, New York, 1981

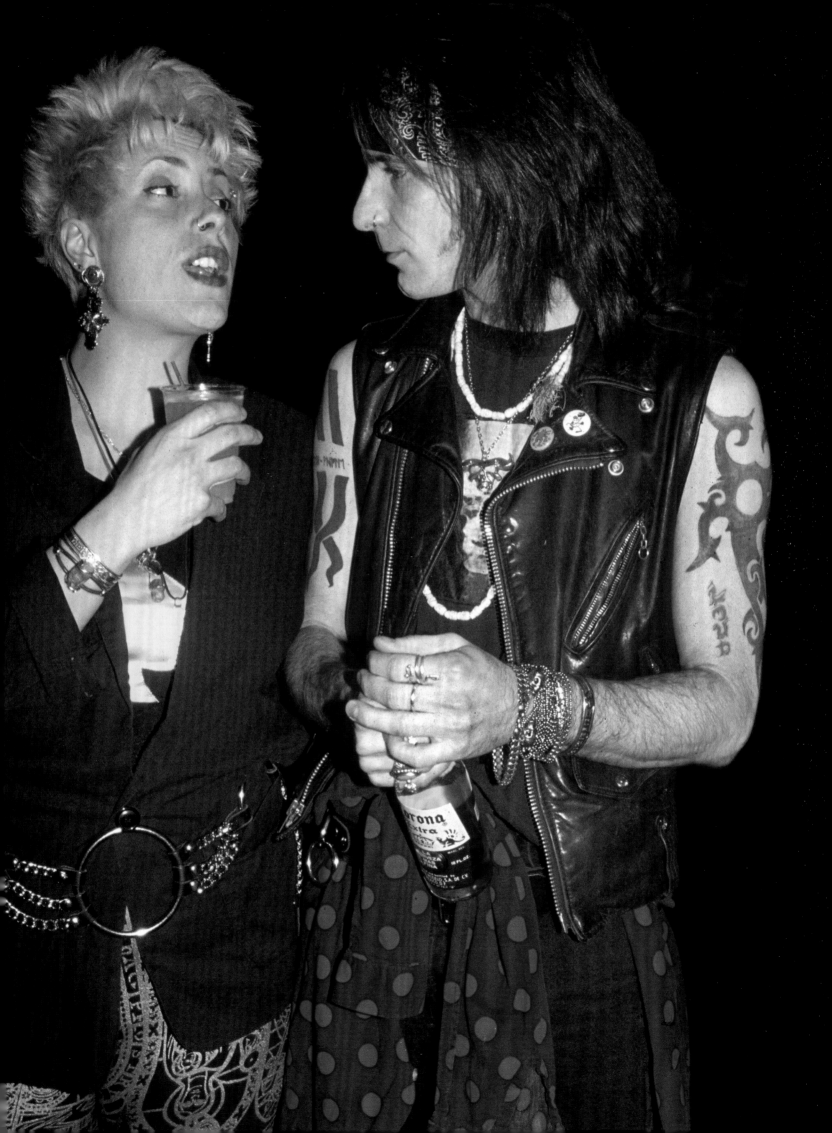

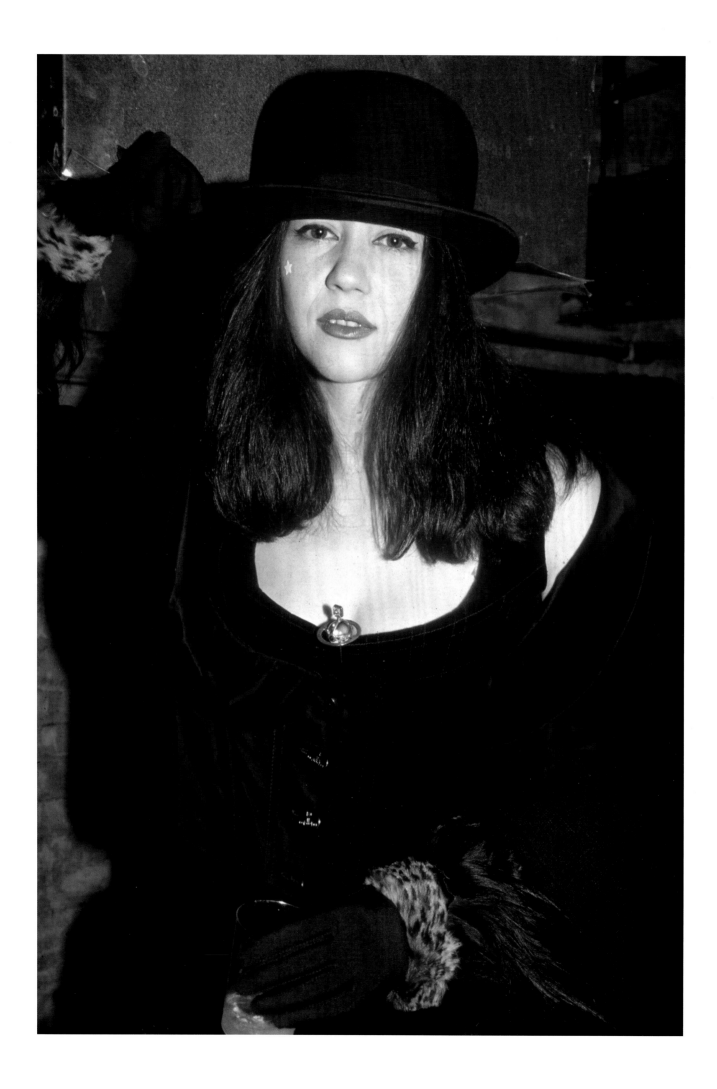

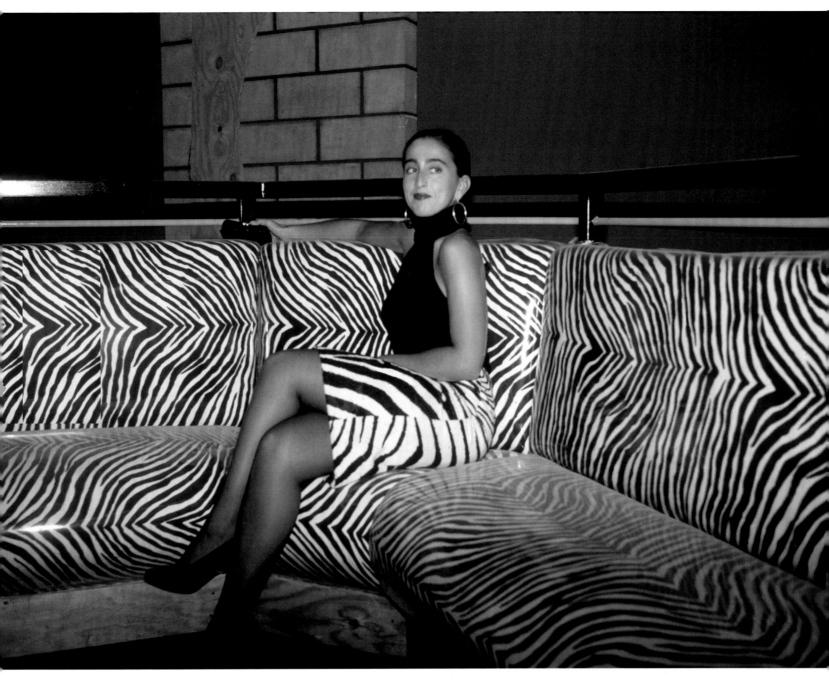

◀ Sally Randall, Area, New York, 1981

Christina Juarez, Le Clic, New York, 1986

CASita MAria Benefit
#19 — Ken Lane
#1 — Treumps Blair Meuss
Barbanll #26 — J Avets
+ Ken Lare

A Helmsle
Pierre

MANSP

Javits —
Ken Lare

Ci Picasa

MEDIA

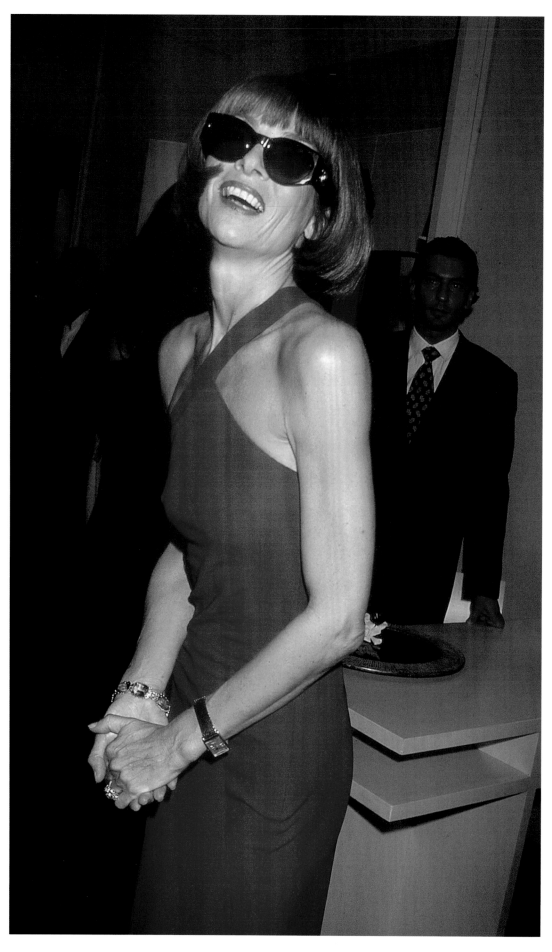

Anna Wintour, Christie's, circa 1990s

▶ Anna Wintour, New York, mid-1990s

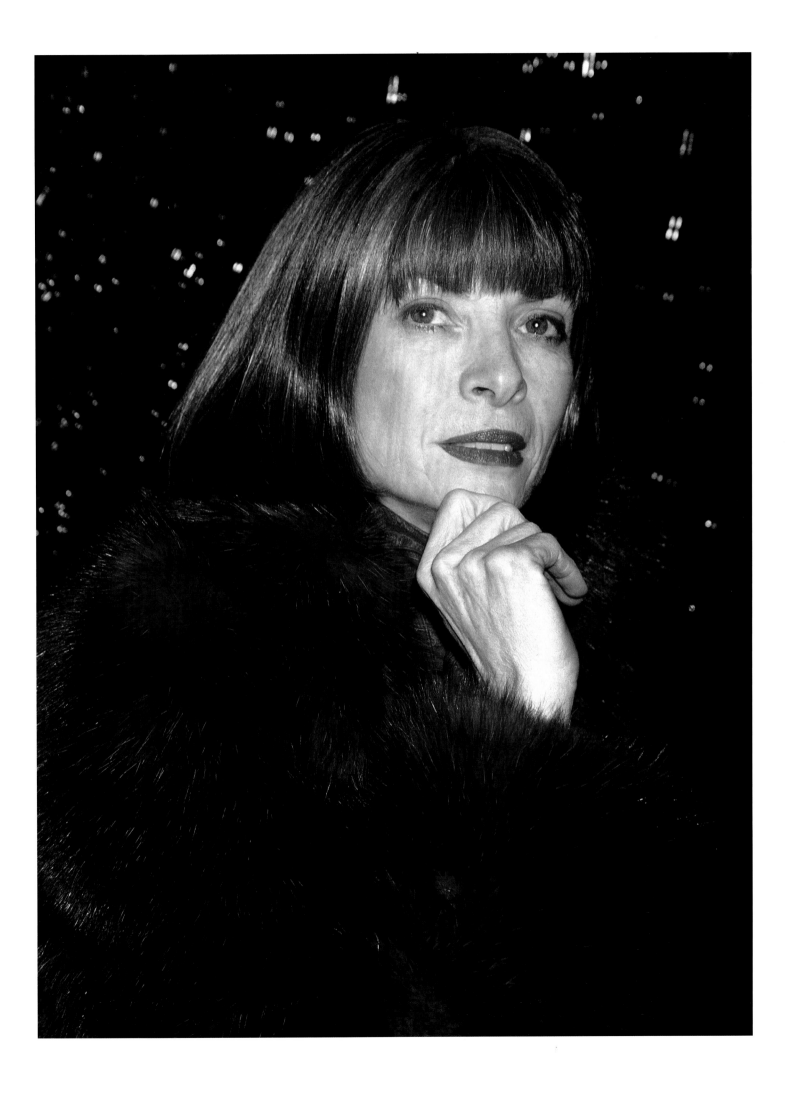

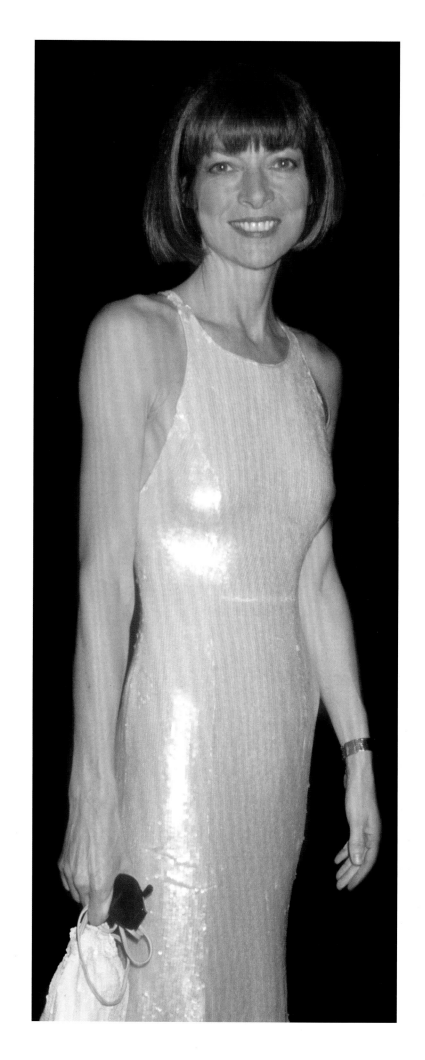

Anna Wintour, 'Salute to American
Heroes' Gala, Tavern on the Green,
New York, 1995

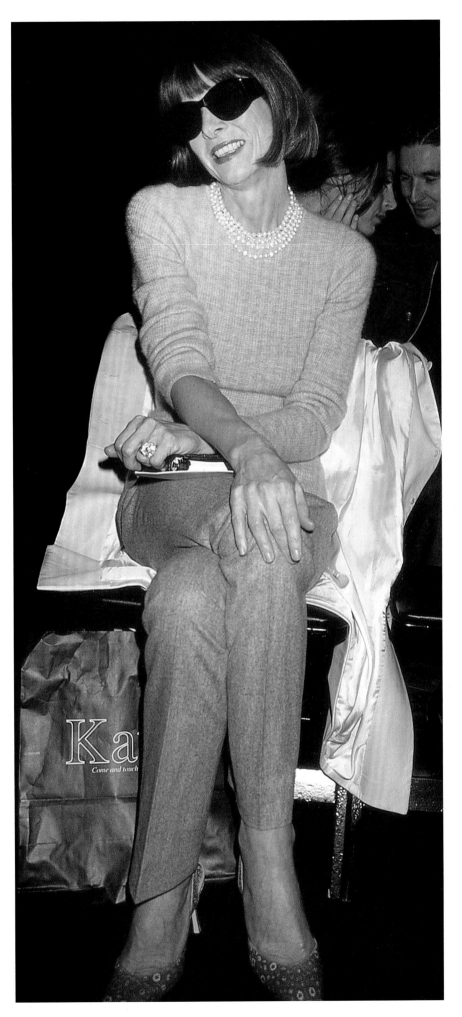

Anna Wintour, fashion show, Bryant
Park tents, New York, 1997

Candace Bushnell, celebration for the
'Versus' Collection, New York, 1998

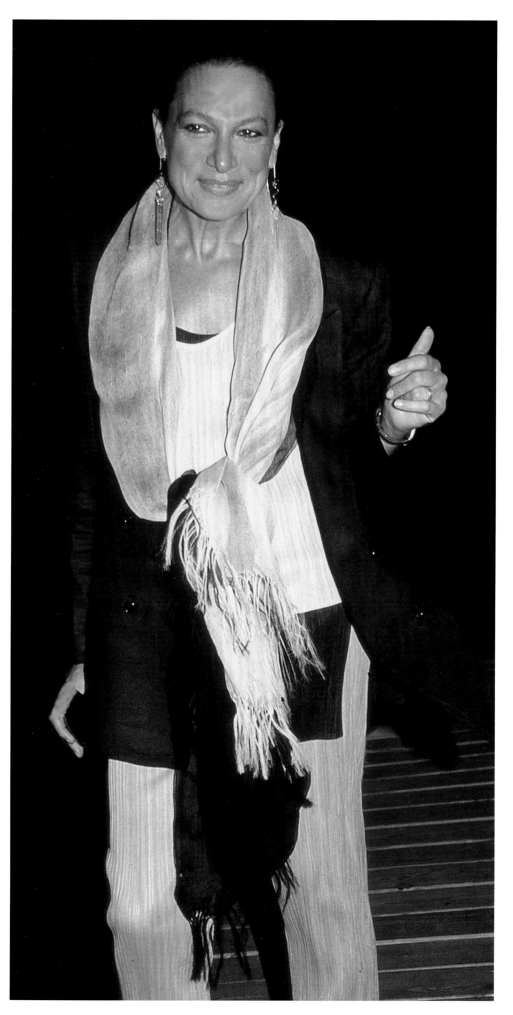

Daniela Morera, Madison Avenue,
New York, 1998

Plum Sykes and Damian Loeb, Mary Boone Gallery, Chelsea,
New York, 1999

▶ Cecilia Dean and Stephen Gan, fashion party, Saks Fifth
Avenue, New York, 1999

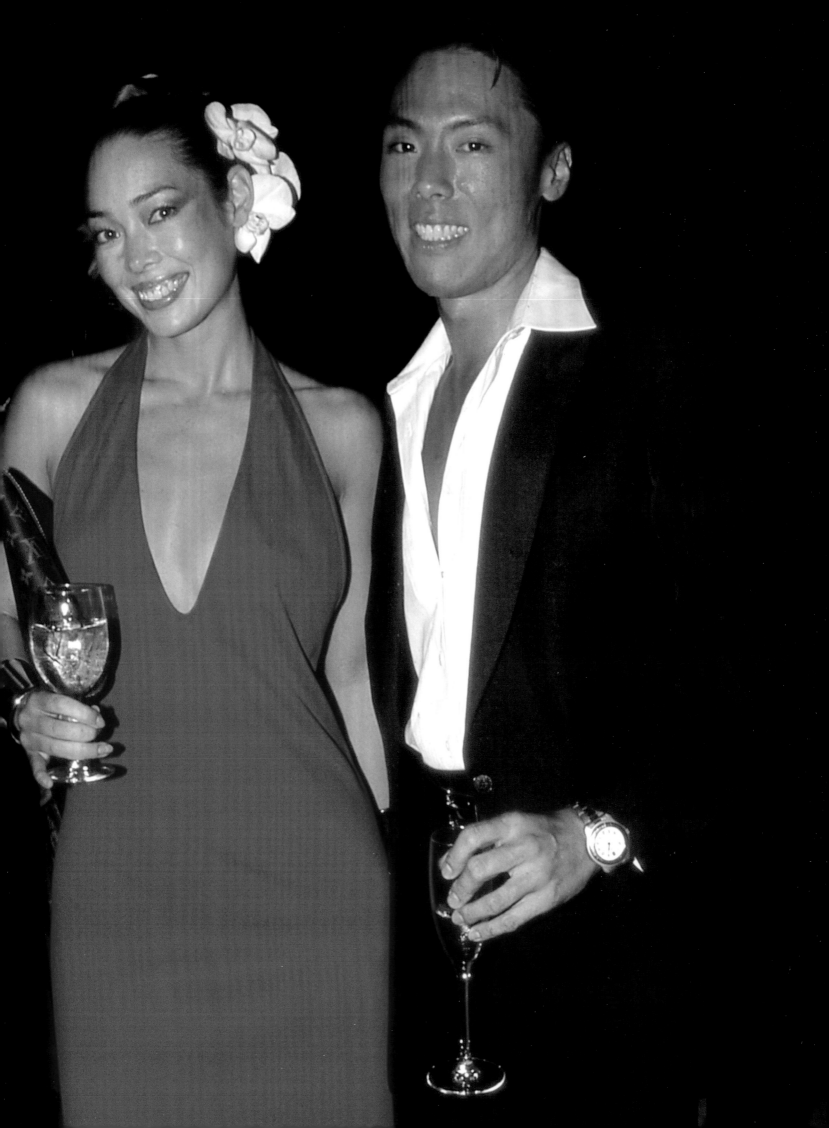

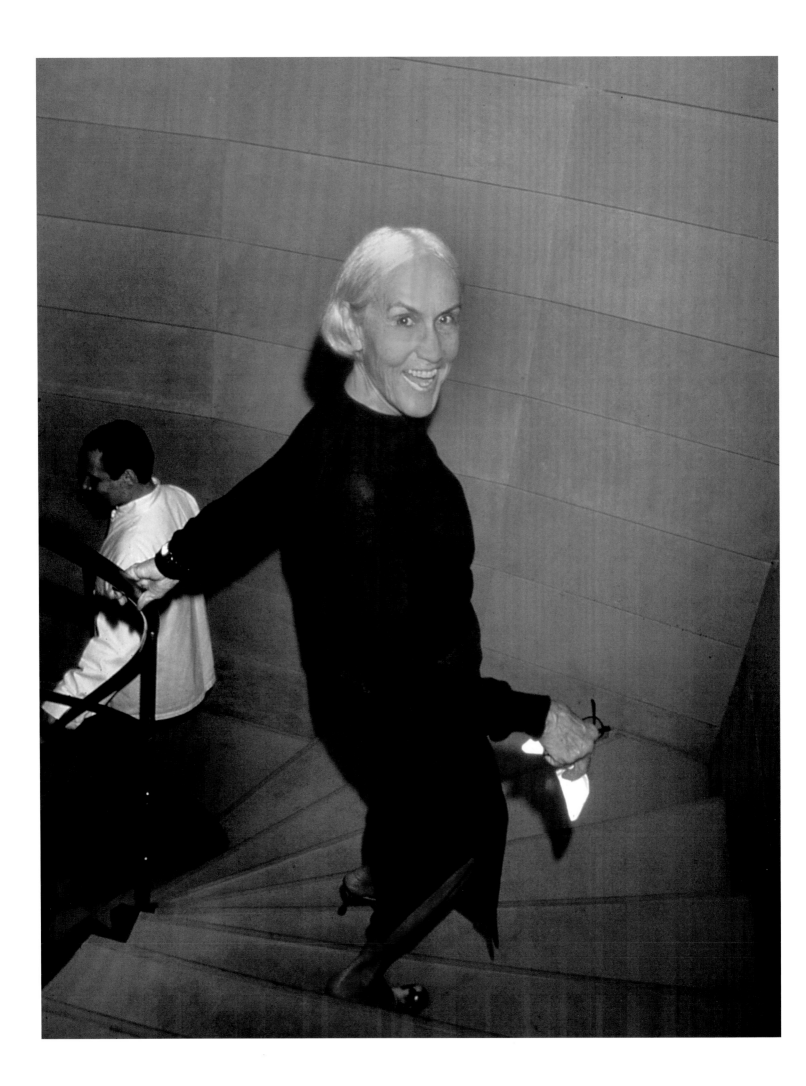

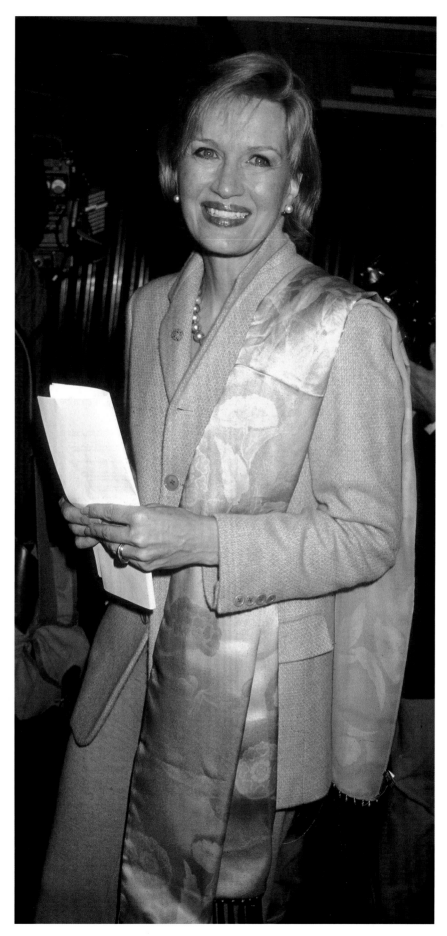

◀ Polly Mellen, cocktail party, Dolce & Gabbana boutique,
Madison Avenue, New York, 1998

Diane Sawyer, film premiere, New York, 1995

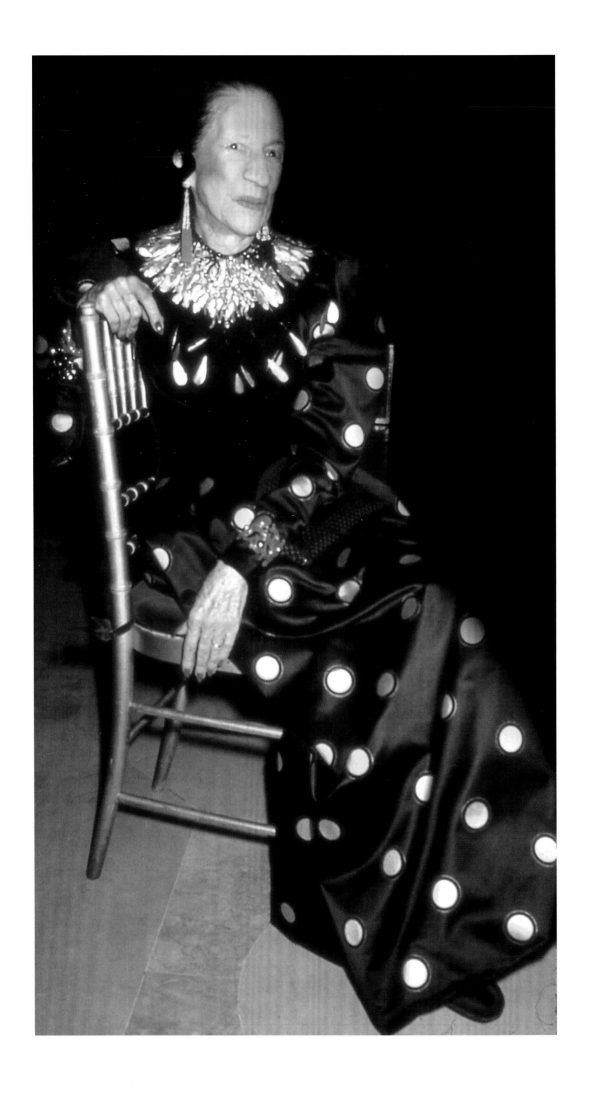

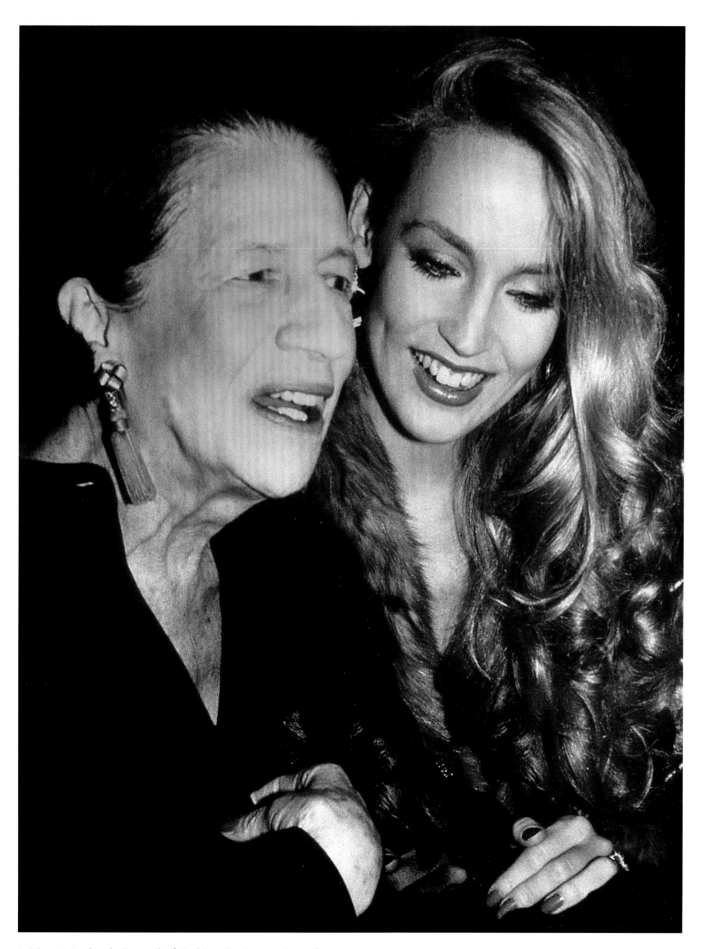

◀ Diana Vreeland, Council of Fashion Designers Awards,
New York Public Library, 42nd Street, New York, 1982

Diana Vreeland and Jerry Hall, Studio 54, New York, 1978